RUSSIAN REVOLUTIONARY ART

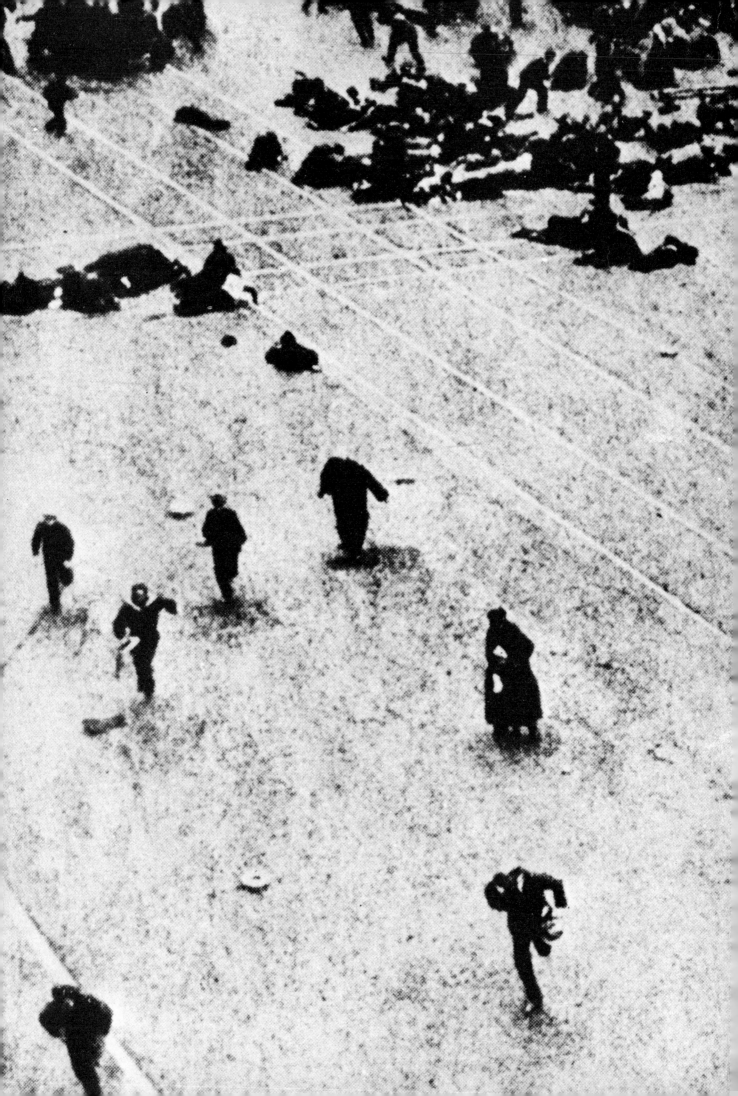

JOHN MILNER

RUSSIAN REVOLUTIONARY ART

ORESKO BOOKS LTD·LONDON

(*title page*)
Revolution on the Streets of St. Petersburg, July 1917
(detail from Plate 1)

ACKNOWLEDGEMENTS

As an increasing number of works come to light from the world of Soviet creative activities in the 1920s, it becomes increasingly possible to discuss works from the original object. The contribution of those galleries who have mounted regular exhibitions of these works to the study of the subject has been very considerable. In connection with this introduction to the subject Annely Juda Fine Art in London and the Galerie Gmurzynska in Cologne have been generous in their assistance. Anyone working in this area, and this includes myself, must be grateful not only for their enthusiasm but also for their substantial catalogues. Necessarily, many works have had to be reproduced from documentary sources, as either the works themselves are not available or their whereabouts are unknown. The photographs of these works are sometimes of poor quality: their importance lies in what they record and preserve of exciting works that have disappeared. I am indebted in this respect to Miss V. A. Rodchenko for her advice and assistance as well as to The Arts Council of Great Britain, to Miss Christine Lodder in London, and to Mr. Kyrill Sokolov and Dr. Avril Sokolov in Northumberland. For typing I am grateful to Mrs. Ann Welsh and Miss Elizabeth Gibson. Sincere thanks are also due to the following for providing photographs and giving permission for them to be reproduced: Annely Juda Fine Art, London; Busch-Reisinger Museum, Harvard University, Cambridge, Massachusetts; Courtauld Institute of Art, London; Fischer Fine Art, London; Galerie Gmurzynska, Cologne; Galerie Jean Chauvelin, Paris; Galerie R, Nuremberg; Kyrill Sokolov, Northumberland; Museum Boymans-van Beuningen, Rotterdam; Museum of Modern Art, New York; National Film Archive, London; Philadelphia Museum of Art, Philadelphia; Robert E. Mates, New York; Solomon R. Guggenheim Museum, New York; Städtische Galerie im Lenbachhaus, Munich; Stedelijk Museum, Amsterdam; Tate Gallery, London; Tretyakov Gallery, Moscow; Victoria and Albert Museum, London; Yale University Art Gallery, New Haven. Finally, I would like to thank those collectors who have kindly given permission to reproduce works in their collections, but who have wished to remain anonymous.

Whilst every effort has been made to clear copyright on illustrations, this has not always been possible, particularly with regard to documentary photographs. The author and publisher apologize for any omissions that arise from this.

The size, medium and location of works have been given whenever possible, but it is regretted that full and detailed information regarding some works has proved impossible to obtain.

For Henry and Edward

First published in Great Britain in 1979 by
Oresko Books Limited, 167 Hermitage Road, London N4 1LZ.

ISBN 0 905368 22 3

Printed and bound in Great Britain by
J.B. Offset Printers (Marks Tey) Limited,
Colchester, Essex.

The City of the Future

The gate flies open, and the city is revealed. What a city! The lattice-like forms of transparent factories and apartment buildings tower up toward the sky. Trains, streetcars and automobiles stand wrapped in rainbows. In the centre is a garden of stars and moons, surmounted by the radiant crown of the sun.

It is to this translucent City of the Future that the Unclean, the collective heroes of the play *Mystery Bouffe* by Vladimir Mayakovsky, at last arrive after singular adventures in a Great Flood, in Hell and in Heaven (Plates 1 and 2). The Flood was the Revolution which began, so the play relates, when an eskimo found the world was leaking and could keep his finger in the hole no longer. The Unclean, as they trudge through Hell, are unimpressed and find its sufferings mild after the 1914–18 War. Heaven, too, seems less than satisfactory. 'This is one institution where we don't belong'. The promised land, which the Unclean seek, lies beyond mythology and religion (Plate 3). When at last its gates are opened, they stand speechless before their own old world transformed:

> Buildings a hundred stories high
> cover the earth!
> Graceful bridges are hung
> between those buildings. And under them
> an abundance of foods!
> Heaps of things!
> On the bridges, the tail ends of trains
> disappear from sight!

The message of the play is that the new society can transform the world by direct action, through work, for a common goal. One of the Unclean, the Locomotive Engineer, turns from this spectacle of the future to his audience. He no longer asks them to believe in him as a character in a play. He turns his back on the sets and speaks to his audience person to person:

> Today,
> these are only stage-prop doors,
> but tomorrow reality will replace
> this theatrical trash . . .

Mayakovsky's play, after all the marvels it describes, destroys its own illusions and rejects its own glittering imagery to underline the potential of the present time; not amongst actors or the creatures of myth, but amongst the real people of his audience, through their control of the material world around them. Instead of asking them to believe in his vision of the future, Mayakovsky (Plate 4) exhorted them to build the new society together; to abandon myth and superstition and

to explore in the smallest work the possibility of movement towards the collective goal, which was to be no less than the transformation of their immediate world, so as to make of their appalling circumstances the city, the society and the promised land of the future. He declared:

No-one can know what immense suns will light our future lives. It may be that artists will turn the grey dust of our cities into multi-coloured rainbows; that the never-ending thunderous music of volcanoes turned into flutes will resound from mountain ranges; that ocean waves will be forced to play on the nets of chords stretching from Europe to America.

This mixture of a striving towards perfect ideals with intense concentration upon the concrete, material, down-to-earth world of the present day provided the vital nerve of Russian Revolutionary art. It is present in the work of all its chief protagonists, as much in the writing of Mayakovsky as in the paintings of Malevich, in the constructions of Tatlin and Rodchenko, or in films by Dziga Vertov. In themselves their works comprised steps towards the communal goal. If they wilfully abandoned self-expression, it was to discover material laws for creative work and to begin constructing the new society, in which culture was to play an active, unprecedented rôle, for every object made was an example of the new order. The construction of objects by creative men became concrete steps towards this goal. As a result art, as it had been known, gave way to construction and took upon itself an inevitable, but new, dimension of social awareness. The history of Russian Revolutionary art is the story of these intentions and of these objects. Those which survive continue to agitate and excite the imagination. They retain the vigour and vitality of their first emergence in the Russian Revolutionary exploration of the relation between art and work and of the artist's rôle in society.

Mayakovsky's vision of the future was not created from a cultural vacuum; indeed a great deal of post-Revolutionary Russian art had its earliest stirrings in the cultural life of St. Petersburg and Moscow in the years before the war began in 1914. At that time many of the latest trends in Western European art were represented in Russian exhibitions and collections. Conversely, Russian artists who travelled westward to Berlin, Munich and Paris before the war often maintained these links in the post-Revolutionary era. It

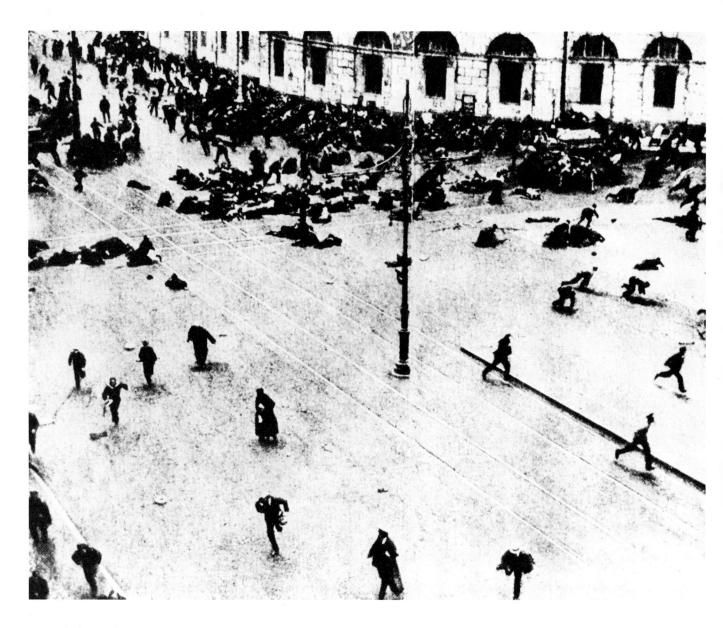

1 *Revolution on the Streets of St. Petersburg, July 1917*
Photograph.

(*opposite top*)
2 Alexander VESNIN and Lyubov POPOVA
The City of the Future
1921. Maquette in mixed media.

This maquette was designed for the proposed mass play *Struggle and Victory* to be directed by
Vsevolod Meyerhold. There was also to be a 'City of the Past' for contrast and airships displaying
slogans. The model figures suggest the intended scale of this project.

(*opposite bottom left*)
3 Vladimir MAYAKOVSKY
Illustration to his Agitpoem-pamphlet 'Neither Sorcerer, nor God, nor Servants of God are a Help to Us.'
1923. Indian ink.

In this satirical and anti-religious drawing a wrathful thunderbolt from Heaven is deflected by
means of a lightning conductor. Anti-religious and anti-clerical themes are common in Maya-
kovsky's illustrations. They are often expressed with more vitality and wit than disillusionment.

(*opposite bottom right*)
4 Alexander RODCHENKO
Vladimir Mayakovsky
c. 1924. Photograph.

The painter and poet Vladimir Mayakovsky was photographed in Rodchenko's studio. Maya-
kovsky's former dandyism is still evident in the concern for appearance which demands an
appropriately decisive, clean-cut and no-nonsense image for the fierce poet of the Revolution. His
gaze is aggressive, his boots and hat immaculate and his setting absolutely bare.

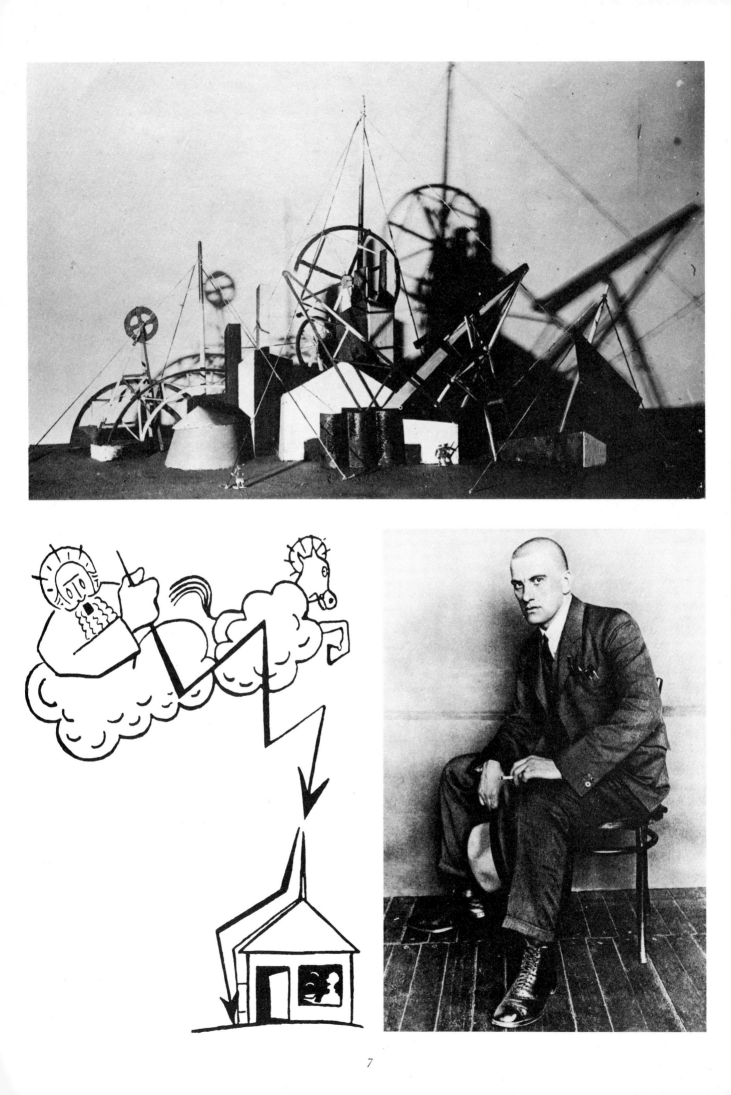

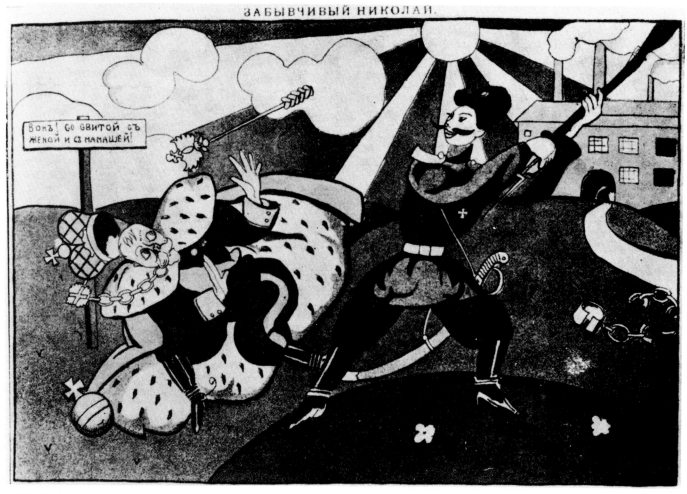

5 Vladimir MAYAKOVSKY
Absent-minded Nicholas
Coloured print.

The overthrow of Tsar Nicholas II by the military is depicted in this *lubok* or popular coloured print. The signpost reads 'Be off with your followers, your wife and your mother!' Beneath the image two couplets by Mayakovsky point the moral: 'Now I shall punish and keep them down!, as, handing out guns, thought the Tsar. He forgot in his haste, in doing all this, that it's workers that soldiers born are.' The implication is that the Tsar, in arming troops to attack workers, discovered that he had misjudged the troops' loyalties.

would certainly be a mistake to consider Russian art in isolation; yet there is much in the nature of the influences which dominated the formative years of those artists who reached their maturity at the time of the Revolution which is distinct from Western European influences. If Russian painters have echoed fashionable themes from Picasso or Matisse, they have also drawn upon the timeless traditions of folk-art, popular *lubki* or wood-block prints (Plate 5) and the spectacular icons of the Russian Orthodox Church. From these last sources came vitality and conviction with no necessary commitment to taste or elegance; from the former came a share in that intense investigation of the basic tenets of art which by 1912 was a world-wide phenomenon, at its most productive and dazzling peak in Paris. Exactly how far Moscow artists were able to keep in touch with new developments is indicated by the appearance at the *Jack of Diamonds* group exhibition in Moscow in 1912 of works

by the Parisian artists Delaunay, Derain, Friesz, Gleizes, Le Fauconnier, Léger, Matisse and Picasso and those by German-based artists from the Dresden Brücke group, Heckel, Kirchner and Pechstein and by those from the Munich Blaue Reiter group, Kandinsky, Macke, Marc and Gabriele Münter.

In addition to links of this kind, much adventurous Russian art before the war shared a cynicism with regard to the art of the past with contemporary circles further West. This cynicism, at times, became almost an irrational hatred and loathing. The Futurists in Italy had perhaps most clearly voiced their opinions in this respect. Marinetti, the figure-head and prime mover of this Italian group, had spoken of destroying museums which to him seemed like mausolea. According to Marinetti, the modern age found its own beauty in the lines and speed of the motorcar and was no longer able or willing to reconcile this beauty with the more static and silent achievements of Michelangelo.

When Marinetti visited St. Petersburg in 1914, he was not made welcome by certain of those Russians, amongst them the poet Mayakovsky, who had independently adopted the aggressive and dynamic name of Futurists. Nevertheless, it is not possible to deny certain similarities of aim and achievement, even after due consideration of their many differences. Marinetti's view of the outward appearance of the modern city was in sympathy with that of Mayakovsky, 'The nightly vibrations of arsenals and shipyards beneath their powerful moons, voracious railway stations devouring steaming snakes; factories attached to the clouds by ropes of smoke... the gliding flight of aeroplanes whose propellers flow like the flutter of flags and the applause of a crowd of enthusiasts.'

Another important link stands out, which, although a literary one, brings Italian and Russian Futurism together. It comprises what the Italian Marinetti called 'Words in Freedom' ('Parole in Libertà'), and what in Russian Futurist circles came to be called 'trans-sense' writing. In Russian, the word used for 'trans-sense' writing was 'za-um', a contraction which means 'beyond meaning'. Marinetti was the chief practitioner in Italy, although other poets followed his lead. His poems of this kind freely employed the space of the page to set out imitative noises and expressive sets of letters which rarely included complete words, but which often, nevertheless, suggested them. Marinetti was expansive and noisy in performance. His impersonation of a railway engine was evidently exhausting. Most celebrated of all was his war poem *Zang Tumb Tumb*, whose title is intended to evoke the sound of gunfire.

'Sound poetry' spread to a number of groups of artists who considered themselves antagonistic to the art of the past and to much of contemporary culture. The Dadaists in Germany were one such group. The Za-um poets in Russia were another. Sometimes the intended effect was outrageous and sometimes musical. In the works of the Russian Futurist poets Khlebnikov, Kruchenykh and Zdanevich, it was related to the structure of language, to the roots and rhythms of words in use. Poems were constructed from units which hinted at meanings without necessarily being completed words of the kind listed in dictionaries. These verbal pieces provided the incomplete, yet public, material for the construction of poems. The process of putting the poem together involved a language more suggestive than explicit, a language which only half explained itself, which investigated as well as employed the syntax, rhythms and roots of spoken or written language. This was 'za-um' or 'trans-sense' poetry. Its importance for the visual and plastic arts was considerable as it provided a precedent and a parallel for the works of Malevich and Tatlin, the two most influential and innovatory figures to rise to prominence on the eve of the Revolution. Malevich had begun to approach painting as an investigation of a pictorial language. He

6 Wassily KANDINSKY
Lyric
ROTTERDAM, Museum Boymans-van Beuningen. 1911. Oil on canvas 94 × 130 cm.

Lyric is full of the tumultuous energy with which Kandinsky was able to fill his paintings, whether in representational works such as this horseman or in the less representational works which were to follow.

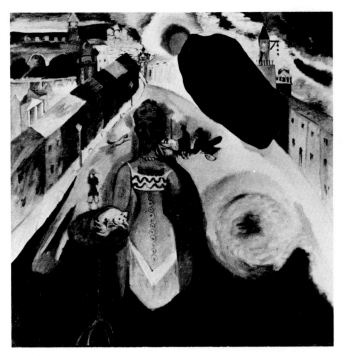

7 Wassily KANDINSKY
Woman in Moscow
MUNICH, Städtische Galerie im Lenbachhaus (Gabriele Münter Foundation). 1912. Watercolour 108·9 × 108·9 cm.

Irrational and provocative displacements of figures and scale were characteristic elements in Russian Futurist paintings by David Burlyuk as well as by Malevich and Puni. Here they are evident in Kandinsky's work too.

had begun to employ fragmented visual imagery in a manner reminiscent of the fragmented words in certain works by his poet colleagues (Plate 8). It is, perhaps, not surprising that he should have come to apply the word 'za-um' to his own paintings at the Union of Youth Group Exhibition held in Moscow in the winter of 1913-14.

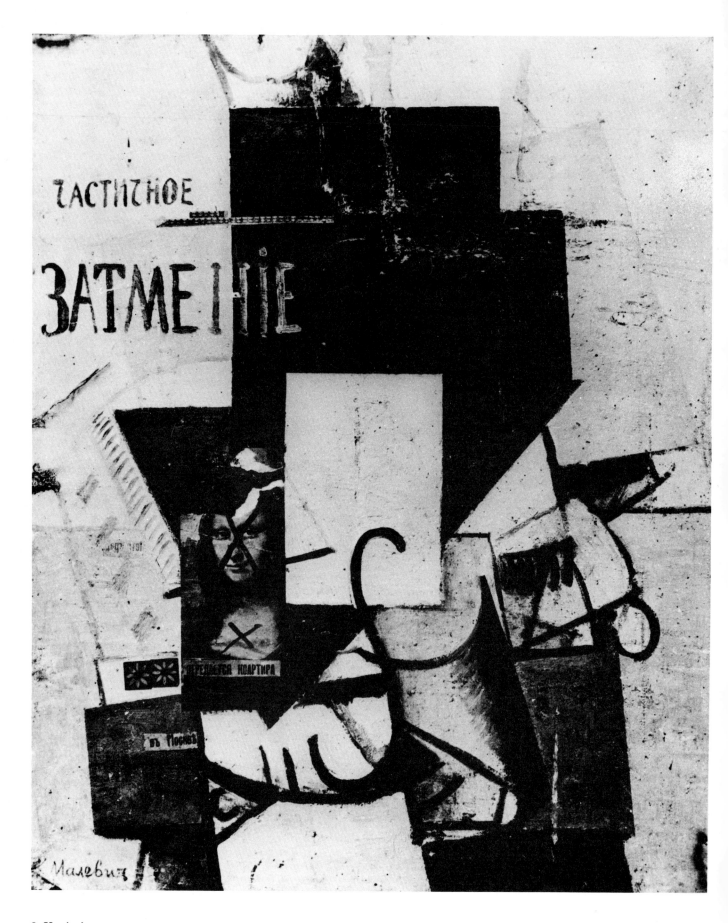

8 Kazimir MALEVICH
Composition with the 'Mona Lisa'
LENINGRAD, private collection. 1914. Oil on canvas with collage 62 × 49·5 cm.

Crossing out the *Mona Lisa* was a characteristically Russian Futurist gesture of disrespect for the Old Masters and the art of the museums. The two words, top left, mean 'partial eclipse'. Beneath the *Mona Lisa* the wording continues 'Apartment to let' and, lower down, 'in Moscow'.

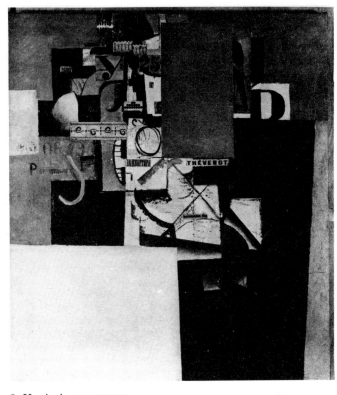

9 Kazimir MALEVICH
Woman at a Poster Column
AMSTERDAM, Stedelijk Museum. 1914. Oil on canvas plus collage 71 × 64 cm.

Cubism offered Malevich a number of pictorial devices, amongst the most basic of which was the inclusion in a single work of a whole variety of different means of representation, so that realistically depicted detail, the inclusion of lettering and numbers and the intrusion of geometrical elements, signs and collage all focus the viewer's attention as much upon the means of representation as upon its object.

Malevich went furthest in investigating art as a kind of language with its own usages and elements. His attitude to recognizable imagery and its relation to the pictorial construction of his paintings was not at all that of a man intending to depict the world as it looks. Consequently, his compositional means comprised speculations upon the very building materials of the visual language. Ironically, this was not at all incompatible with the study of past art, particularly in the field of composition or pictorial construction, in the use made of recognizable imagery or in the rôle in a painting of the artist's brushmarks and the textures they imposed upon the materials used. This was part of the history of the pictorial structures devised and employed to make art intelligible at different times. The Renaissance tradition comprised one such explicit and immensely elaborate system of compositional and perspectival devices.

The very structure of the visual language had evidently evolved and changed with the passage of time. Just as the world of the Italian Renaissance was historically remote from the Russian Revolution, so was its cultural climate and, as a result, the pictorial devices employed with great brilliance during the

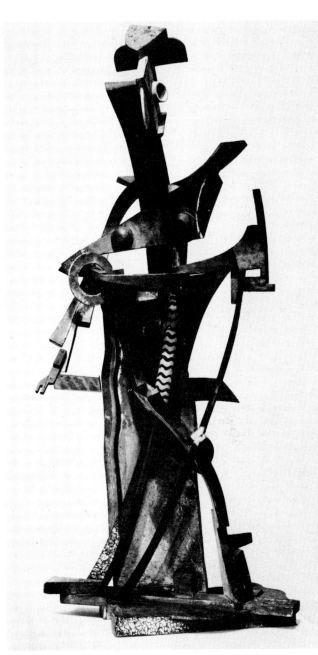

(*right*)
10 Vladimir BARANOFF-ROSSINÉ
Symphony No. 1
NEW YORK, Museum of Modern Art (Katia Granoff fund). 1913. Polychrome wood, cardboard and crushed eggshells. 160·6 × 72·4 × 63·5 cm.

In building his figure from a variety of materials, Baranoff-Rossiné was responding to the lively and iconoclastic ideas of the Russian Futurists. His choice of materials, particularly the inclusion of broken eggshells, exemplifies his irreverent attitude to the traditionally respected materials of the sculptor. His attitude is nevertheless distinct from those of his contemporaries Alexander Archipenko and Vladimir Tatlin.

Renaissance were no longer effective and were, for many artists, a positive hindrance. Malevich, in crossing out the image of the *Mona Lisa* (Plate 8), made public his frustration in this respect. In doing so, he created a new image, the crossed-out culture of the past, a recurrent, iconoclastic element throughout European art during the years of the 1914–18 War. 'Why look to the past,' wrote Mayakovsky, 'with so much of the

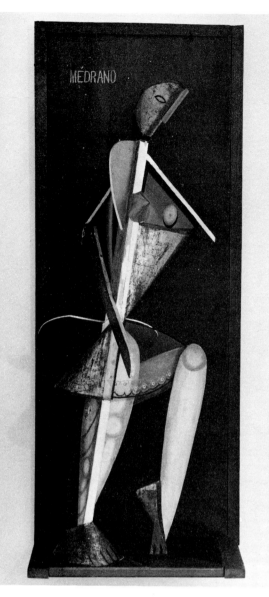

(*above left*)
11 Alexander ARCHIPENKO
Médrano II
NEW YORK, Solomon R. Guggenheim Museum. 1913. Wood, metal, glass and oil cloth
127 × 51·7 × 43·2 cm.

Archipenko examined painterly techniques and devices in a number of early constructions, bringing about a unity of painting and sculpture. Tatlin, a painter turning to three-dimensional work, approached a comparable synthesis, but without Archipenko's devotion to the figurative image.

(*above right*)
12 Alexander ARCHIPENKO
The Bather
PHILADELPHIA, Philadelphia Museum of Art (Louise and Walter Arensberg collection). 1915. Wood, paper, metal 50·8 × 29·2 × 2·5 cm.

Archipenko's use of the figure was in sympathy with Cubist sculpture in Paris, yet his early attempts to find a synthesis of different materials led to clear resolutions of problems in construction which in themselves were close to the concerns of Tatlin and others who had largely abandoned figurative work.

future before us.' The Locomotive Engineer in *Mystery Bouffe* asks 'Why do folks go to museums anyway? All around us treasures are heaped up high.'

Russian Futurists went to great lengths to prevent their works from conforming to long established cultural norms (Plate 10). Respectability in this sense was anathema to the pre-Revolutionary group. Some

of the poets produced books printed by hand on wallpaper and one volume had a button sewn on to the cover. Their anthologies bore names like *Explodity, The World Backwards* and *Piglets*. They were outrageous, too, in the manner of their dress and their public behaviour, adopting an aggressive but inverted dandyism, in which the affectation of elegance employed by the

13 Kazimir MALEVICH
Black Square
Reproduced from *Suprematism: 34 drawings,* published in Vitebsk by the *Unovis* collective, 1920.

This is a later printed version of Malevich's painted *Black Square* and comes from a publication
which charted the chief developments in his Suprematist painting.

dandies of Oscar Wilde's generation was superseded by
an affectation of brutal absurdity. The Futurist poet
Kamensky tells of a Futurist excursion for which
Mayakovsky wore an orange suit, whilst his colleague,
the painter-poet David Burlyuk, sported a multi-
coloured coat with silver buttons and a top hat. 'With a
crayon,' wrote Kamensky, 'Mayakovsky drew an

airplane on my forehead. On Burlyuk's cheek he drew a
dog with an upturned tail . . . Exactly at noon we put
wooden spoons into our lapels and went to the
Kuznetsky Bridge.' Mayakovsky's rejection of past
culture was voiced as clearly as that of Malevich. He
spoke of 'spitting out the past' which was 'like a bone
stuck in our throats.' In the manifesto *A Slap at the*

14 Kazimir MALEVICH
Suprematist Painting
AMSTERDAM, Stedelijk Museum. After 1920. Oil on canvas 72·5 × 51 cm.

Suprematist painting at its height displayed a complex and dynamic control of picture-space: geometrical forms and elements of dense colour provided an illusion of gliding and tilting through space. The sense of foreground and background that this entailed was criticized by the Constructivists as being redolent of traditional picture construction and thus too rich in opportunities for self-expression.

Public's Taste, he declared that the past masters of Russian literature, Pushkin, Dostoevsky and Tolstoy, 'must be thrown overboard from the steamer of the Present Time'.

The links between these poets and Russian Futurist painters were extremely close. Malevich, in particular, had collaborated on a number of projects with the poet Alexei Kruchenykh and had provided revolutionary costumes and sets for his short-lived opera *Victory over the Sun* in 1913. He thoroughly shared their disrespect for the past and was eager to discover a means of communication appropriate to the twentieth century. These two considerations were mutually supporting and each encouraged the evolution of the other.

The last of Malevich's paintings to employ recognizable imagery show alternative systems of depiction in conflict against each other (Plate I, see page 17). Styles of painting and pictorial devices of widely differing

kinds are made to confront each other, so that what the painting adds up to is a complex and hybrid work based upon the artist's investigation of different pictorial languages. It was only later, from 1915, that he devised a coherent language of forms which he felt was appropriate to the age of flight (Plate II, see page 18).

In his works immediately prior to 1915, Malevich devised new means of structuring or composing his paintings. In these so-called 'alogist' works he presented fragments of images, such as those of a man, a church, a sword, a fish, a rectangle of colour, lettering, a collage object, and constructed his painting from their pictorial conflict. The canvas became an arena for the conflict of images and objects, which, in their fight to dominate the viewer's attention, often overlap in front of the focal point of the canvas so that they partially cross each other out. Two of these works are inscribed, a Cubist device, with letters in Russian, which mean 'partial eclipse' (Plate 8). Malevich saw this way of applying images of conflicting scale and kind as a pictorial equivalent of the poets' 'za-um' language. The work of this period reveals the extent to which this 'overlapping' space of the paintings had an iconoclastic aspect to it. The presentation of half a cow or figure in a painting by Malevich is the pictorial equivalent of an incomplete verbal form in a 'za-um' poem, yet Malevich also crossed out and indeed referred to the fact in the inscription 'partial eclipse'. In one painting, which includes a real thermometer (Plate I, see page 17), the object is forced to measure up to pictorial events and space, and vice versa. In the painting with the representation of the *Mona Lisa* (Plate 8) the fact that the stuck-on reproduction of Leonardo's painting is crossed out points clearly to a rejection of the past. However the formal device is more subtle than this in itself might suggest, for the collaged object comes to function as one of the several disparate kinds of images which are played off against each other. The crossed-out image has become a new motif within the painting.

In 1915, in a single and simple work, Malevich spelled out an adventurous escape from traditional criteria into fresh fields of creativity with a new pictorial language, which he christened Suprematism, as his guide.

Suprematism began with a single frontal painting of a black square placed centrally on a square canvas. Malevich described the *Black Square* (Plate 13) as a clear, decisive and economical break with the past, an iconoclastic act, a painting-out of all the constructions of the past, a reduction of the whole output of the world's accumulated pictorial traditions to as blank an image as possible, complete with the utter rejection of narrative content that this entails. The *Black Square* was intended as a full stop in the history of art. Like a full stop the *Black Square* provided the still silence before the new beginning, which, in fact, it brought about itself, being the clearest and simplest starting point, the single

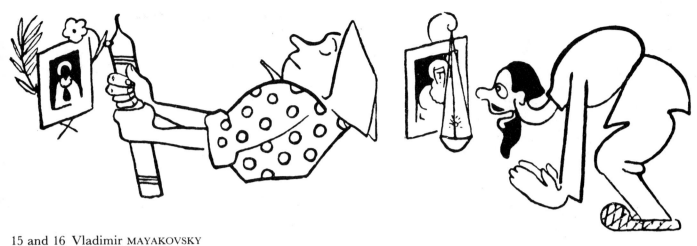

15 and 16 Vladimir MAYAKOVSKY
Two Illustrations to his Agitpoem-pamphlet 'Neither Sorcerer, nor God, nor Servants of God are a Help to Us.'
1923. Indian ink.

The woman is depicted by Mayakovsky praying around the clock without a moment's rest. The man, too, is ridiculed for his prayers before an icon.

origin of Suprematism, which was elaborated step by step by Malevich upon this minimal, yet firm, basis.

The *Black Square* is heir to the overlapping images of his 'partial eclipse' paintings, for the eclipse has progressed and is now total. It is also possible that the imposing frontality of image characteristic of certain icon paintings and their lack of pictorial perspective contributed to the extreme frontality and blankness of this painting. It was a pivotal work, at once destructive and creative, at once negative and positive, a nothing, a nil and a still centre. It was a blotting-out of pictorial imagery from the past and at the same time a mystical icon for the new age, hardly more than a diagram of an idea, yet a potent influence upon the formative years of Soviet art. Not least amongst the lessons it provided was that art should reflect and comment upon contemporary culture. This work, which rejected and undermined so many values traditional to art, its tastefulness, its rôle as a vehicle for self-expression or religious conviction, even its beauty, seemed to reject art itself and question the use of it at all. Yet the *Black Square* provided a beginning as well as an ending, not only for the work of Malevich, but for the emergence of a new cultural awareness.

The *Black Square* embodied a vital aspect of this emergent culture, namely a growing tendency to reject illusion in favour of fact, the replacement of representation by presentation. The *Black Square* had reduced narrative content to zero. The viewer could see in it no kind of inherent possible development. The eye was unable to establish paths through the painting for it housed no lines or colours. There was always and only the blank black square. Illusionism had been abandoned. It was not a painting of a square, it was a square. Presentation had superseded representation. The viewer was obliged to look at the painting's surface as he was denied the opportunity to look into the painting. The painting was no longer a window onto nature, or even onto the mind; it was pre-eminently a made object.

Mayakovsky's play *Mystery Bouffe* undermined illusion with its references to factual material concerning the history of recent events and to the immediacy of performing in a theatre before an audience, who are thus reminded not to mistake illusion for reality. The world was revealed as an arena for real events in which the future could be physically moulded. The artist and non-artist were urged to involve their creative abilities not in artificial and imaginary worlds, but in the concrete material world about them. Amongst a whole range of creative men and women, many of whom had been painters before the Revolution, easel painting came to be viewed as self-indulgence. The creative person was encouraged to abandon his easel and his academy which were remote from life and to decorate the streets, to devise and execute an art that was public and no longer private, that had no need of galleries, but was accessible in the squares. Art as self-expression was again under attack with the demand that it be public expression and the outward manifestation of a new culture, which after 1917 was identified with the social revolution. 'Artists and writers,' wrote Mayakovsky, 'have the immediate duty to get hold of pots of paint and brushes to illuminate, to paint all the sides, foreheads and chests of cities, railway stations and the ever galloping herds of railway carriages.'

Something of the iconoclastic element of pre-Revolutionary years contributed to those festivals which marked the dismantling of the Romanov dynasty (Plates 15 and 16). Many artists were called upon to decorate enormous squares and buildings and to design those re-enactments of recent events which brought contemporary historical fact and theatre so close together. The overthrow of the Tsar brought an entire period of Russian culture to a close. His usurpation was depicted in pageants and posters, as

was the overthrow of Kerensky's government. The most ambitious of re-enactments were undertaken with the closest involvement of artists who brought to the astonished inhabitants of Moscow and Petrograd the dynamic forms of a public and rhetorical modern art. In 1918, for example, a mass-spectacle depicting the storming of the Winter Palace was performed on an enormous scale before the actual Winter Palace with the protagonists represented several times to make them visible (Plate 17). The buildings were covered with enormous painted scenery and an iconoclastic festival was made of the public re-enactment of recent history.

No actual damage to the art treasures of pre-Revolutionary collections was legally permitted. Looting was forbidden and the ownership of art works was made over to the government. Large collections of material were made and temporarily assembled in art depositories under the care of Maxim Gorky. Victor Shklovsky recalls arriving in Petrograd in 1919:

I joined a commission whose name I don't remember. It was supposed to be responsible for the protection of antiquities and it was located in the Winter Palace.
That was where Lunacharsky received people . . . The platoon on duty was armed with swords from Damascus; Persian miniatures lay on the floor. In the corner I found an icon depicting the Emperor Paul as the Archangel Michael . . .

In the very beginning of cultural activities under the new communist régime, the concept of a public art was accepted as basic and vital. The windows of empty shops were filled with posters, hoardings were painted, trams, trains and whole squares were filled with dynamic images and shapes. Monuments, however temporary, were erected at the earliest possible opportunity and every form of public art was encouraged to embody the ideals of the Bolshevik régime. Mayakovsky described this concept:

From this day forward, with the abolition of Tsardom, the domicile of art in the closets and sheds of human genius—palaces, galleries, salons, libraries, theatres—is abrogated. In the name of the great march of equality for all, as far as culture is concerned, let the free word of creative personality be written on the corners of walls, fences, roofs, the streets of our cities and villages, on the backs of automobiles, carriages, streetcars, and on the clothes of all citizens . . .

After the Bolshevik Revolution in October 1917 many of the figures who had been, at least in part, active anti-artists shifted their attention and their creative endeavour in an attempt to work towards defining the new culture. On the level of a monumental public art a great deal was to be achieved. An iconic figure, the image of a superman against an unreal background who is associated with a whole iconography of gestures and events, survived, not only in socialist-realist painting, but even in the photomontages of Lissitzky or Rodchenko or in the more abstract format of the dynamic diagonal thrust of so much that was public and monumental in post-Revolutionary art (Plate 18).

If anti-art activities and attitudes survived in leftist

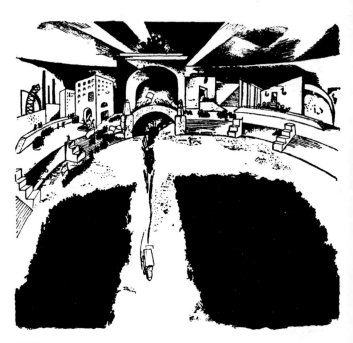

17 Yuri ANNENKOV
Sketch for the Re-enactment of the Storming of the Winter Palace 1918. Ink.

Annenkov's sketch was part of the celebrations to mark the first anniversary of the October Revolution. In front of the façades of the Palace enormous stages were erected depicting the rulers' city, which was called the 'White stage' and is to the right of Annenkov's drawing. The workers' 'Red stage' is to the left, with its suggestions of factory chimneys. Opposing forces can be seen in confrontation on the bridge. A lorry with troops has entered the square where the massed audience-participants wait.

(*opposite*)
I Kazimir MALEVICH
Private of the First Division
NEW YORK, Museum of Modern Art. 1914. Oil on canvas with collage of postage stamp and thermometer and paper 53·6 × 44·8 cm.

Malevich utilized Cubist devices of lettering, collage and fractured images in piecing together this painting that also incorporates flat geometrical areas of paint. In the *Private of the First Division*, Malevich contrasts different methods of depiction and representation. The thermometer and postage stamp are, for example, actual objects incorporated in the work. Yet large areas of flat colour and clearly representational details, such as the ear of the private, are strong enough in their appeal to the eye to balance the elements of collage. Lettering, the numeral 8 and the cross from a medal or epaulette provide further evidence of Malevich employing different kinds of representation and visual references within a single painting. As a result, his painting, not executed in a single technique, comprises an examination of a whole range of methods balanced one against another. Cubism provided Malevich with a valuable precedent for examining the means of painting and the nature of representation.

art circles into post-Revolutionary years, and there is no dearth of evidence that they did, it was as part of the attempt to define the rôle of culture no longer in purely aesthetic terms, but in relation to the material demands of politics.

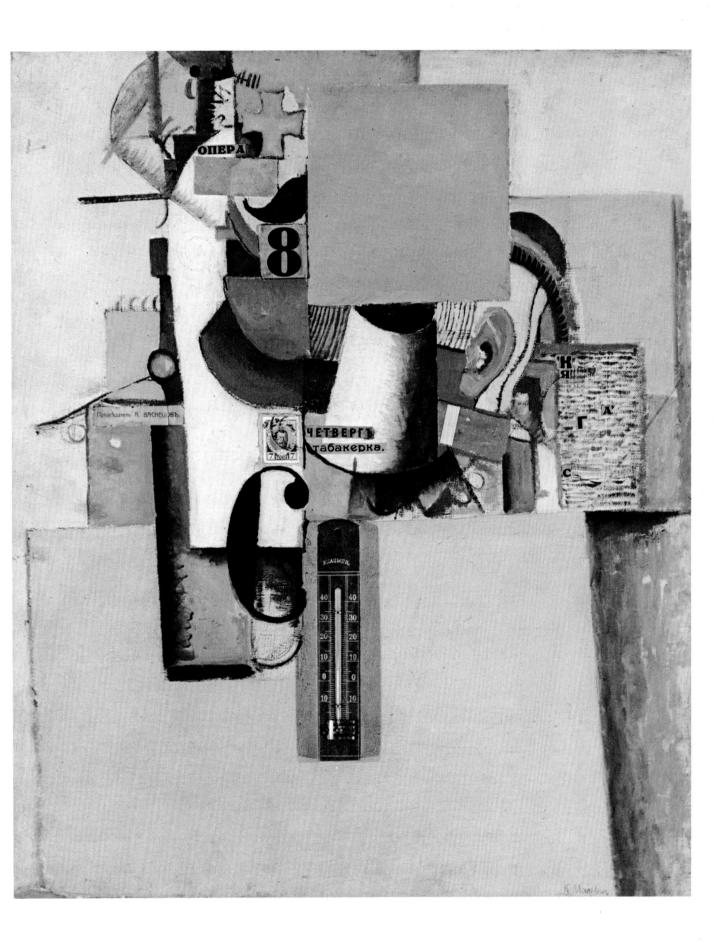

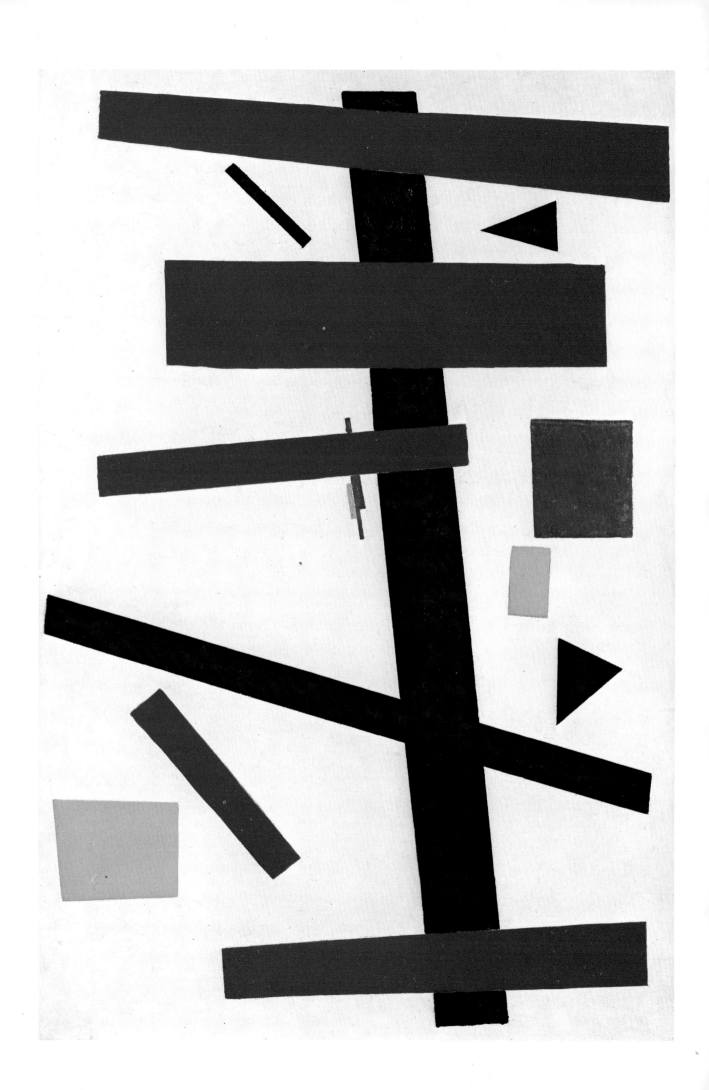

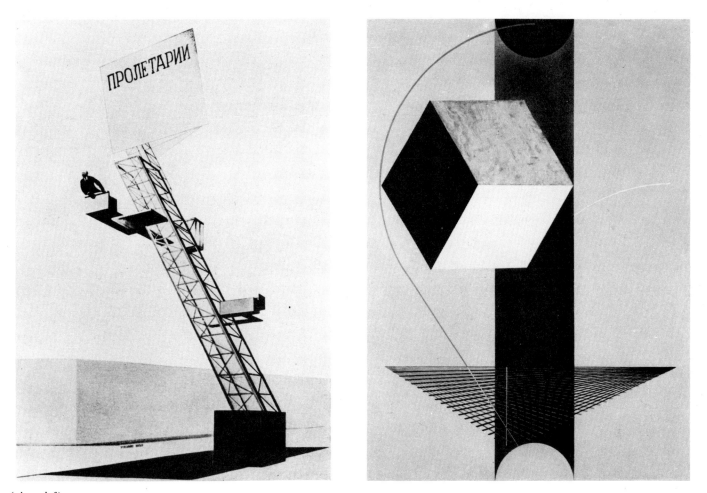

(above left)
18 El LISSITZKY
Lenin Podium
1920. Photomontage. Signed: Unovis.

The word 'Workers' appears on the screen. The diagonal lean was used as an image of dynamic force. The figure of Lenin on the balcony gives a scale to the project, which remained unexecuted.

(above right)
19 El LISSITZKY
Proun 99
NEW HAVEN, Yale University Art Gallery (gift of the Société Anonyme). c. 1924. Oil on wood 129·4 × 99 cm.

Lissitzky's paintings and prints contain aspects of both Suprematist and Constructivist painting. His ultimate allegiance was closer to the Suprematist picture space of Malevich, for he continued to rely upon illusionistic space containing solid forms engaged in a geometric narrative.

(opposite)
II Kazimir MALEVICH
Supremus No. 50
AMSTERDAM, Stedelijk Museum. 1915. Oil on canvas 97 × 66 cm.

The most impressive quality of the complex Suprematist paintings by Malevich was a dynamic control of the space suggested by geometrical form and by colour. *Supremus No. 50* is a dense matrix of spatial planes indicated by the apparent recession of particular forms, each implying deep pictorial space hollowed out within the white of the painting, by means of changes of scale, overlapping, hints of perspective and the spatial effects of colours. Nothing in the painting is static and each element appears in a particular spatial relation to every other one. This hollowed-out space is balanced by the dominance of the flat picture surface. All of Malevich's forms, however much they may appear to glide in a white space, are painted in flat colour that resolutely emphasizes the surface flatness of the painting. Across this flat expanse the conflicts and contrasts of his elements provide a strong rhythmic structure. In *Supremus No. 50* this structure is provided by the decisive repetition of the long red rectangles against the steeply sloping strut in black. Malevich leads the viewer back into intricate and deeper illusionistic space through the tilted black rectangle crossing this structure.

The celebrations of the first anniversary of the October Revolution were a memorable and potent early example of the new public art. Echoing Mayakovsky's demands, 'art into the street' became a much-repeated cry. Under the most arduous conditions, Russian artists must, at times, have given streets and squares in Petrograd, Moscow and elsewhere a hint, at least, of the strange and decorated city dreamt of by the poet (Plate 22). By the time that the English novelist Arthur Ransome saw Moscow in early February 1919, the winter weather had done its worst with the great anniversary street decorations. Something of the atmosphere is preserved in his notes:

Walking about the town I found it dotted with revolutionary sculptures, some very bad, others interesting, all done in some haste and set up for the celebrations of the anniversary of the Revolution last November. The painters also had been turned loose to do what they could with the hoardings, and though the weather had damaged many of their pictures enough was left to show what an extraordinary carnival that had been . . .

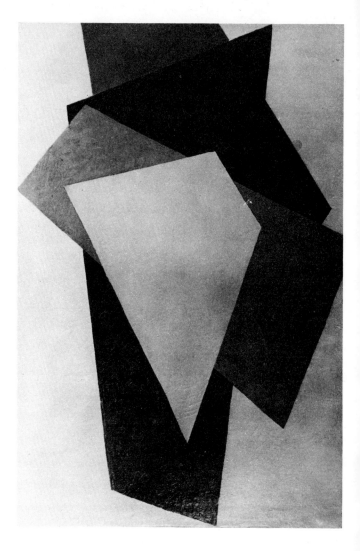

20 Lyubov POPOVA
Pictorial Architectonic
LONDON, Annely Juda Fine Art. 1916–17. Oil on canvas 105·5 × 70 cm.

In those paintings by Popova which use forms comparable to Malevich's Suprematist paintings, a sense of construction within the picture replaces the sense of flight and weightlessness of Malevich.

(opposite top)
21 Lyubov POPOVA
Architectonic Painting
NEW YORK, Museum of Modern Art (Philip Johnson fund). 1917. Oil on canvas 80 × 98·4 cm.

The generation of younger artists who admired the examples set by both Malevich and Tatlin undertook an exploration of pictorial structure without recourse to the floating and open space of Malevich or the material construction of Tatlin. Popova's 'Architectonic Paintings' of 1917 were amongst the strongest and clearest works of this analytical phase.

(opposite bottom)
22 Natan ALTMAN
Street Decorations, Petrograd
1918. Photograph.

The scale of these decorations was impressive and their colours were strong. The form of Suprematist painting had left the canvas and had begun to inhabit the street. These were temporary structures which transformed the square through the thrust and energy of the most recent developments in painting.

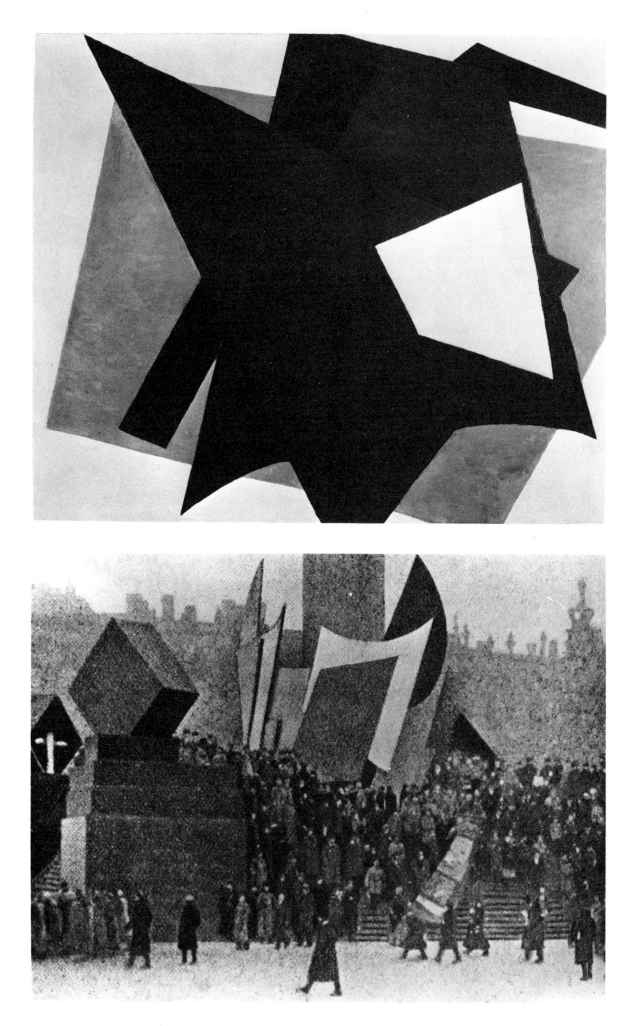

The Culture of Materials

IT HAS BEEN suggested that both Malevich and Mayakovsky shared a distinct attitude to subject matter. They tended to move, in certain respects, away from an art of illusory images towards the construction of art works with material that was non-representational, in that it stood for itself, be it Malevich's *Black Square* (Plate 13) or *Vladimir Mayakovsky,* a Futurist tragedy by Mayakovsky about himself. It has been mentioned, too, that Malevich was interested in Cubism. Tatlin was another artist inspired by Cubism and he took one step further this idea of the rejection of representation and its replacement by the presentation of real material (Plate 23).

Vladimir Yefimovich Tatlin was born in 1885, thus he was older than Malevich and Mayakovsky. He had visited Picasso in Paris before the war and, after seeing Cubist reliefs in Picasso's studio, Tatlin, too, began to turn away from figurative painting in favour of Cubist constructions in various materials. It is curious that Tatlin's sculpture retains many of the qualities of painting. In this lies a clue to the attitudes and aims which motivated the works. After the first distinctly Cubist pieces, which employed recognizable Cubist still-life subject matter, Tatlin systematically extended his works forward in space. Although most of his work is now lost or destroyed, it is known from photographs that the earlier relief constructions retained the rectangular format of easel painting (Plate 24). The fact that the forms were in relief counteracted any illusionist tendency towards recession into the background, in other words, the 'base' of the relief. In place of painted forms appearing to recede in pictorial space, in Tatlin's work real forms come forward from a solid base, about which there is nothing illusory and are manipulated, with or without paint, in real everyday space, showing the tendency of illusion to give way to presentation.

In a painted composition one form may be faded into another and regular *passage* effects can take the viewer smoothly across the painting, in and out of its suggested illusion of depth. Once composition is attempted in relief, gravity and the natural reluctance of materials to join together or even hang together, begin to affect the compositional possibilities. Consequently, and this is vital to Tatlin's art, composition became a process of construction and construction arose out of the proper-ties of the particular materials employed. The very processes of creative organization are intimately related to the promptings of the materials involved. Tatlin, in taking one large step from painting towards sculpture, isolated two elements vital to the new culture, as many of the artists of the 1920s were to understand. In isolating the study of material, its workable characteristics, and construction, which arises out of material rather than aesthetic considerations, Tatlin provided the principles of a new approach to investigating creative work, which were hailed as revolutionary because they stepped away from that world of tasteful predilection and nuance, to which painting is so perfectly sensitive, towards the concrete world of real stubborn material existence. Tatlin was seen as the source of an art independent of personal taste or self-expression, an art which left the security of imagined or illusory picture space to organize material reality on a basis of clear construction and the study of the materials involved. All this was to be crucial to the analysis of art proposed by Constructivist practitioners and critics. Its anti-art element is clear. The proposition states that painting and sculpture are artificial domains devised by artists wishing to seek solitary self-expression, thus supporting an ivory-tower view of creative activity. His followers and sympathetic critics saw in Tatlin's adoption of the study of materials and of construction an impersonal and objective rôle for the artist, or, as he came increasingly to be called in these circles, the constructor.

Tatlin's constructions, with the exception of two quite different works, never completely abandon the format of painting, or relief, to become free-standing sculptures. Once the activity involved had been defined as construction rather than painting or sculpture, the distinction between the two arts was no longer a strictly relevant consideration. Indeed, the study of construction came to be viewed as a basic activity of creative work which was seen to be functioning as much in film, theatre or architecture as it was in painting or sculpture. Tatlin in his famous *Tower* (Plate 25), subsequently sidestepped the distinction between sculpture and architecture. Once construction had replaced composition, the particular *métier*, be it architecture, graphic design or sculpture, became simply a function of the material from which the work

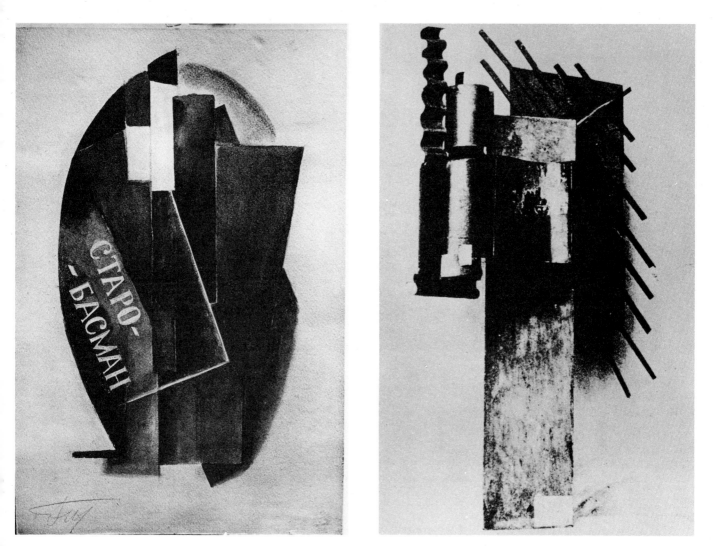

(*above left*)
23 Vladimir TATLIN
Study for Board No. 1
LONDON, Annely Juda Fine Art. 1917. Watercolour, gouache and gold paint on paper 44×30 cm.

This study was from the work in egg tempera, oil and primer in the Tretyakov Gallery, Moscow.
The suggestion of an oval format and the lettering still recall Cubist painting. The inscription
reads 'Staro-Basman'. The Starobasmannaya is a major street in Moscow.

(*above right*)
24 Vladimir TATLIN
Counter-relief
Whereabouts unknown. Mixed media 100×64·2 cm. Documentary photograph.

This relief was exhibited at the Van Diemen Gallery in Berlin in 1922.

was to be built.

The extent to which Tatlin maintained a vestige of pictorial, as opposed to sculptural, space in his reliefs is revealed in his brilliantly original and quite unprecedented corner-reliefs, in which the cluster of forms corresponding to the 'image' in a non-objective painting, is suspended on wires spanning the angle of the corner of a room. It is as if the purely material or physical qualities of a painting, such as its being a support for images which in turn is hung from a wall, are isolated and made an evident and important part of the work. The illusory space, the picture surface which traditionally claims so much of the viewer's attention and which functions as a support for illusionistic images, is diminished and the purely physical constructional elements are magnified and made more evident. The shift was away from illusion towards presentation. Tatlin's contribution made that 'presentation' an explicit example of creative activity with real materials, a deft adjustment of a small part of the material world according to new cultural values.

This ostensibly objective investigation coincided with the anti-aestheticism of certain of Tatlin's admirers and followers and much of the theory of critics and practitioners who were to call themselves Constructivist derives from Tatlin's example. Many of Tatlin's works are pre-Revolutionary in date, but his isolation of the cardinal principles of construction and

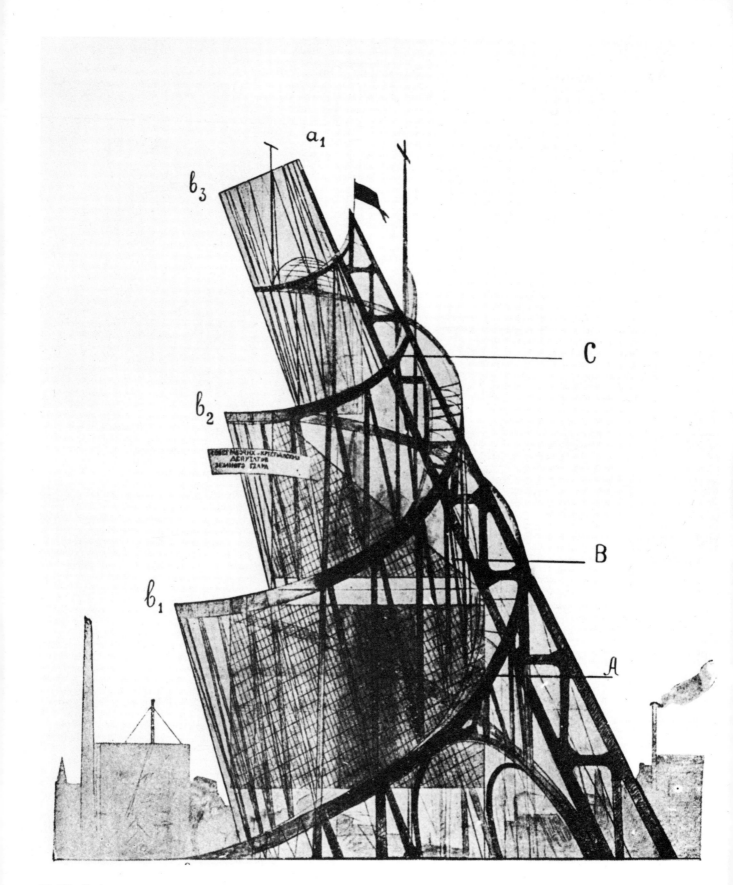

25 Vladimir TATLIN
Tower or *Monument to the Third International*
1919–20.

This side elevation was published in 1920 in the pamphlet on the Monument written by the critic Nikolai Punin, who commented that: 'the spiral is the line of movement of mankind liberated. The spiral is the ideal expression of liberation. With its heel set against the ground, it escapes from the ground and becomes a sign of the renunciation of all animal, earthly and low ambitions.' The banner, suspended from the Monument, reads: 'The Soviet of Workers' and Peasants' Deputies of the World'.

the study of materials laid the basis for a theory of art which attempted to abandon entirely decisions of taste in favour of materialist construction. Having reached this point, Constructivists were happy to proclaim the death of art, a sentiment echoed amongst German Dadaists. 'Art is Dead', read the placard at a Berlin Dadaist exhibition, 'Long Live Tatlin's Machine Art.'

It is not necessary to think of Tatlin's art as particularly mechanistic. Many of his followers, both in Russia and Germany, were far more interested than he was in machine forms. Tatlin's *Tower* was his only mechanized work (Plate 25). Even when that reached a sufficiently advanced stage for a large model to be made, its revolving suspended rooms, which, when executed, were intended to be enormous and to revolve at differing speeds, had to be cranked round by a small boy with a simple handle device on the occasion when the model of the *Tower* was exhibited in Moscow (Plate 26).

Machinery exemplified clarity of construction, economy of means and the exploration of the inherent qualities of different materials, and certainly engineers provided inspiring examples for Constructivist sculptors (Plate 27). Many Constructivists emulated their precision and control, for example, the Hungarian Constructivist László Moholy-Nagy in his *Light-Space Modulator* (Plate 28). Tatlin, however, did not seek to emulate engineers and to search for such emulation is to miss an important quality of Constructivism, namely that it was an investigation of creative work and not an adulation of machinery. Tatlin's reliefs meticulously avoid machine forms and yet the works reveal their materials and their construction with a clarity which appears to have been one of Tatlin's perfections. A joint, for example, between two sheets of metal is more likely to be clarified as a separate element in a construction by threading and knotting wire through drilled holes than by welding, a process which might well have better suited the engineer or machine-constructor.

The aim of the engineer is to distribute his material, steel, for example, in such a way as to fulfil a particular, practical, pre-determined function, whilst the aim of the Constructivist's creative work is to investigate the material to hand and to reveal the formal language permitted by, and characteristic of, that material. Tatlin did this with pieces of metal, wood and glass, but others who followed his lead worked, for example, in film. The comparison between the engineer and the Constructivist is parallel to the comparison between the cinematographic engineer, whose working material is celluloid and the Constructivist director, whose material is not only celluloid, but the qualities of film as a material which can be made intelligible. The director's 'material' includes the relative impact of one image upon another, the impact of techniques of splicing or fading and even the speed of the film's action

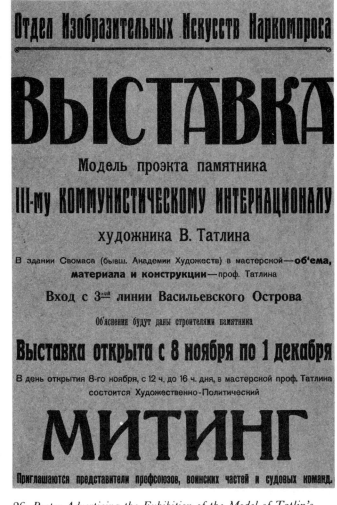

26 *Poster Advertising the Exhibition of the Model of Tatlin's Monument to the Third International*
1920.

The exhibition took place in the Studio of Volume, Material and Construction at the Petrograd Free Studios from 8 November to 1 December 1920. The poster invites representatives of professional bodies, military units and naval commands to an artistic-political meeting in Professor Tatlin's studio on the opening day.

and changes of viewpoint. These techniques form the natural language for this material, film, which permits the director to use it on a cultural level (Plate 29).

Some Constructivists, particularly those working in a sculptural or architectural context, used forms and constructional devices borrowed from engineers. Naum Gabo, who was trained as an engineer, produced precise, potent and, in their own terms, economical images of the new age (Plates 30–33). The intention, however, was to investigate the formal language of particular kinds of engineering construction rather than to devise either machinery or panegyrics to machinery, although certain of Gabo's monuments do contain such an element. Gabo's case is, however, a particular one. His theory of art was at odds with that of the Constructivist followers of Tatlin in that he believed in the necessarily personal and mysteriously intuitive nature of artistic knowledge and insight. For Gabo the extension of a construction outwards in space

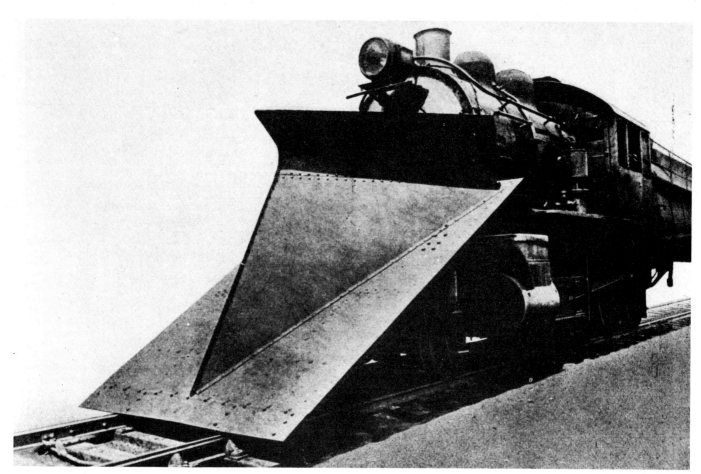

27 *Locomotive Snowplough*
Photograph.

An impressive example of the shape of mechanized efficiency as it was admired by El Lissitzky and the writer Ilya Ehrenburg, this photograph of a locomotive snowplough was published in their Berlin-based tri-lingual periodical *Veshch'-Objet-Gegendstand* in 1922 and in Ehrenburg's theoretical text *And Still It Turns*, also published in Berlin in 1922.

(*opposite*)
28 László MOHOLY-NAGY
Light-Space Modulator
CAMBRIDGE (MASSACHUSETTS), Harvard University, Busch-Reisinger Museum (gift of Sibyl Moholy-Nagy). 1923–30. Steel, plastics and wood 151 cm. high including base.

The *Light-Space Modulator* was a mechanized sculpture by a Hungarian follower of the Constructivists and of Lissitzky. Moholy-Nagy did much to popularize formal aspects of Constructivism, first at the Bauhaus in Germany and subsequently in Chicago. His interest in mechanized movement was largely visual; this work constitutes a celebration of the precise and shining forms of machinery in a manner largely absent from kinetic works by Russian Constructivists.

from a central core provided an equivalent to structures observed in certain natural organisms. This was not the case in Tatlin's work, although it is surprising how close to nature and natural form both men were in their attitudes. Gabo compared his constructions with the symmetries of growth outwards from the centre of a flower and Tatlin designed a glider of bentwood to carry man engineless and silent through the air, as close as he could be to natural forces. These examples emphasize that it is an error of approach to think of Constructivism in purely mechanistic terms. Tatlin's investigation of materials was in no way incompatible with the study of natural form and the mechanics, for example, not of steel wheels or radio valves, but of bird flight.

A consideration of Tatlin's design for a *Tower* (Plate 25), apart from perfectly exemplifying the contemporary demand for a public and monumental art, reveals a further and quite distinct approach to the question of the investigation of construction. Although the materials, both for the model and for the full scale building, were evidently an important consideration, as it was to be taller than the Eiffel Tower and in all probability was to straddle the river Neva in Petrograd, the structure of the monument nevertheless relies upon geometrical devices which in themselves are immaterial; they could be adapted to, and executed in, a variety of materials. The glass halls are separated from the double spiral of the steel struts, but the steel struts conform to a structure more natural to a geometer's investigation than to an exploration of the properties of materials. In this reconcilation of geometrical form to

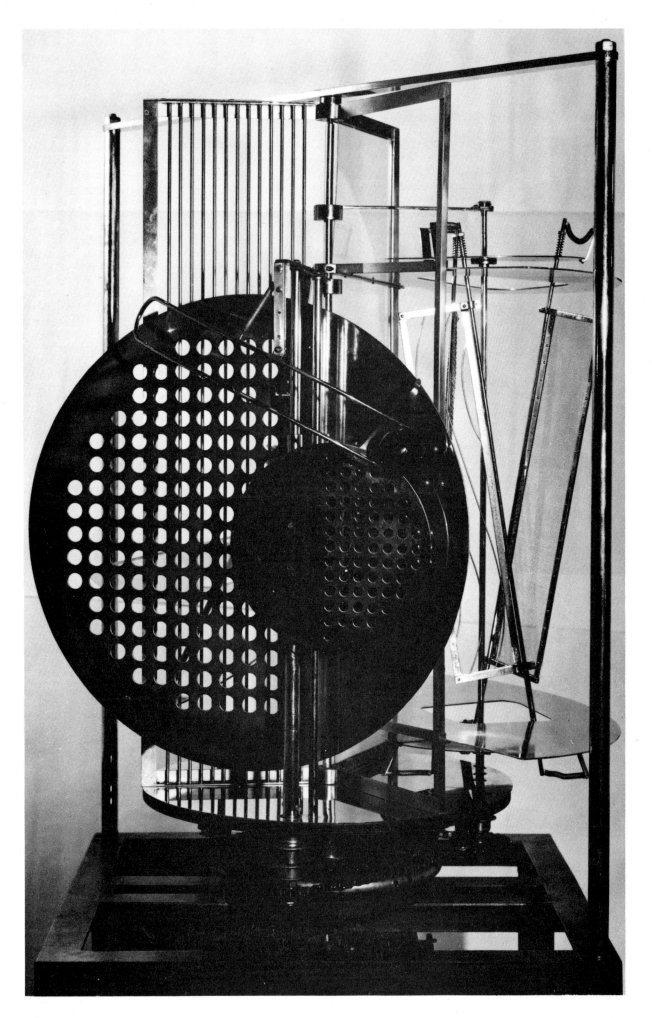

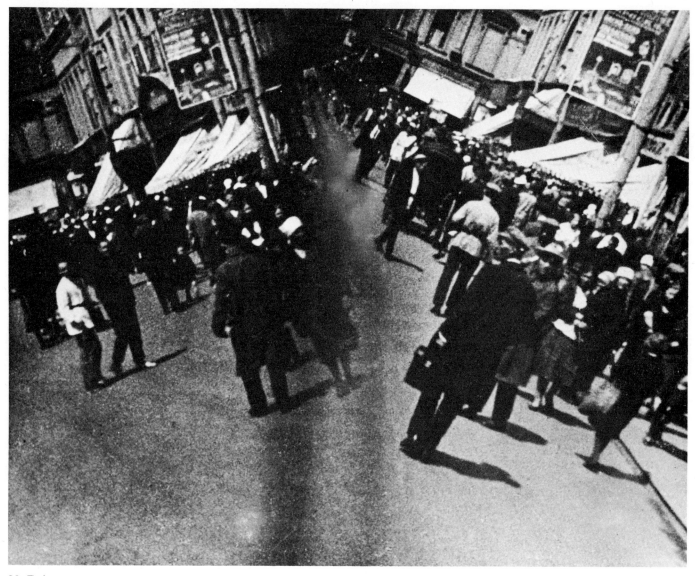

29 Dziga VERTOV
Still from 'The Man with the Movie Camera'
1929.

The Man with the Movie Camera was made in conjunction with the cameraman Tissé. In Vertov's works, techniques derived from collage and photomontage were translated into film. It is never possible for the viewer to forget that he is watching a film as the fact of its construction is kept so much in evidence. His subject matter in this film is the life of the Soviet city. The only individuals whose identities are maintained throughout the film are the cameramen, whose efforts revealed the city, aided by rhythmic and dynamic film editing and not by narrative.

(*opposite*)
30 Naum GABO
Head of a Woman
NEW YORK, Museum of Modern Art. c. 1917–20, after a work of 1916. Celluloid and metal
62·2 × 49.5 cm.

The space described by a corner had been utilized by Tatlin in his suspended corner reliefs of 1914–15. Here Gabo, in a clearly representational work, makes use of three planes at right angles in a corner that is part of the work. The effect is of a deep relief that does not project beyond the front edge of the base. Meticulously cut and shaped materials describe the surfaces of the head with the edges of their planes.

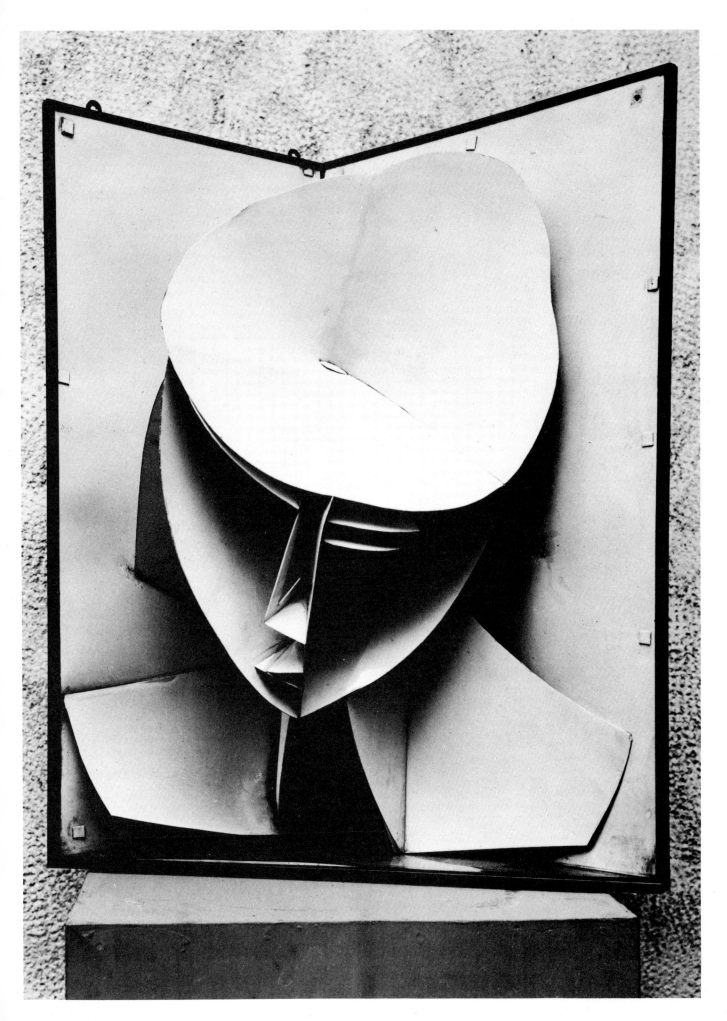

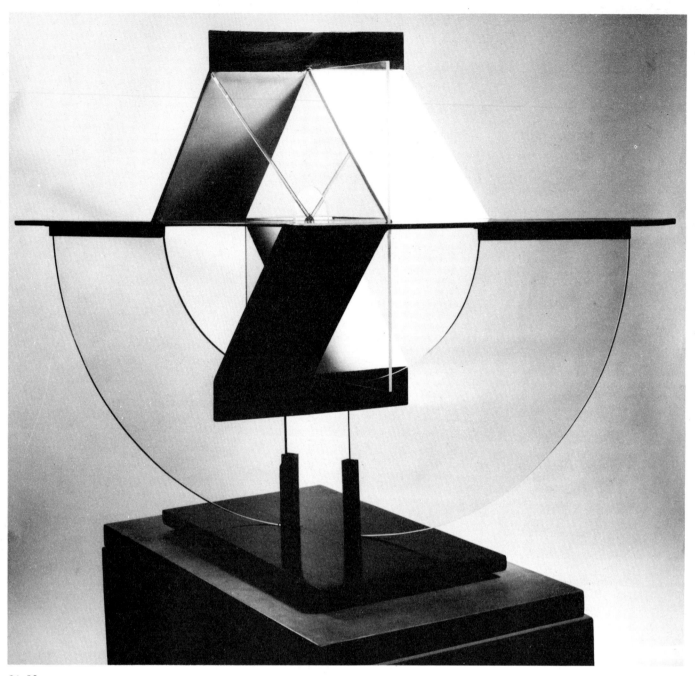

31 Naum GABO
Construction in Space with Balance on Two Points
NEW HAVEN, Yale University Art Gallery (gift of H. Wade White). 1925. Plastic, glass, metal and
wood 66·7 cm. high.

Here the materials are manipulated with all the sophistication and precision of the engineer. The
elaborately symmetrical structure is based upon mathematics as much as materials. The artist does
not evolve his construction out of the materials, but imposes his predetermined structure on the
materials used.

the demands of weight-bearing structure and the pull
of gravity, Tatlin moves much closer to the field of
engineering and away from the study of materials. The
intuitive element in Tatlin's study of construction
remains the device of the double leaning spiral,
capturing so spectacularly the idealistic social thrust of
the period.

Tatlin's study of material construction in his reliefs
and corner-reliefs provided a basis for investigative
work in the new post-Revolutionary teaching studios,
especially *Vkhutemas* in Moscow, the Petrograd Free

Studios and the theoretical institutions of which the
Institute of Artistic Culture (*Inkhuk*) was the most
important. In their work with found materials, the
constructors Lev Bruni, Georgiy and Vladimir Sten-
berg and Kazimir Medunetsky, all reflected the
influence of his pioneering work. Similarly, Tatlin's
investigation of geometrical and reproducible con-
struction found an echo in other works by the Stenberg
brothers, by Ioganson and, most succinctly, in the work
of the Constructivist, Alexander Rodchenko (Plates 35,
36 and III, see page 35).

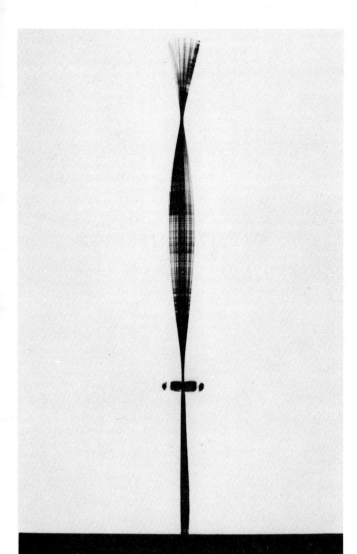

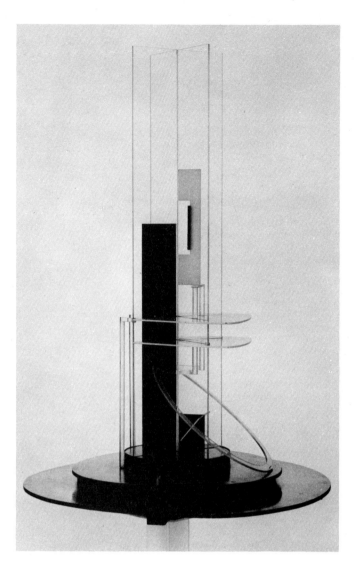

(*above left*)
32 Naum GABO
Standing Wave
LONDON, Tate Gallery. Metal rod with electric motor 58·5 cm. high.

Gabo's trembling wire defines its shape by movement only. When its motor is switched off, the shape of the piece is a single vertical line.

(*above right*)
33 Naum GABO
Column
NEW YORK, Solomon R. Guggenheim Museum. 1923. Plastic, glass, metal and wood 104 cm. high.

Gabo's handling of materials was closer to engineering than to the Constructivism of Tatlin or Rodchenko. His acute control of the cutting and finishing of his elements is a sign of his use of materials to embody predetermined forms and his refusal to permit the elements at hand to determine construction.

It has been suggested that Tatlin, in defining the activity of the creative person as that of construction, had established the basis of an underlying theme of post-Revolutionary art. He had many followers and by no means all of them achieved Tatlin's characteristic clarity of construction. Some followers of Malevich were vitally interested, too, by Tatlin's example; consequently, for example, in some of his works Ivan Puni borrowed forms from Malevich, yet constructed some and painted others. Malevich's complex Suprematist paintings are full of a dynamic thrust which makes the non-representational forms he uses float and glide in a suggested picture space. This development grew from the germinal *Black Square* (Plate 13). In the work of his friend and follower Puni, the forms are anchored in each other, some being executed in materials other than paint and fixed on to the painting to make a relief (Plate 37). El Lissitzky, whose admiration for the work of Malevich is evident equally in his paintings and prints, similarly adapted the floating picture space of Malevich to ends of his own, in themselves closer to construction in real materials as

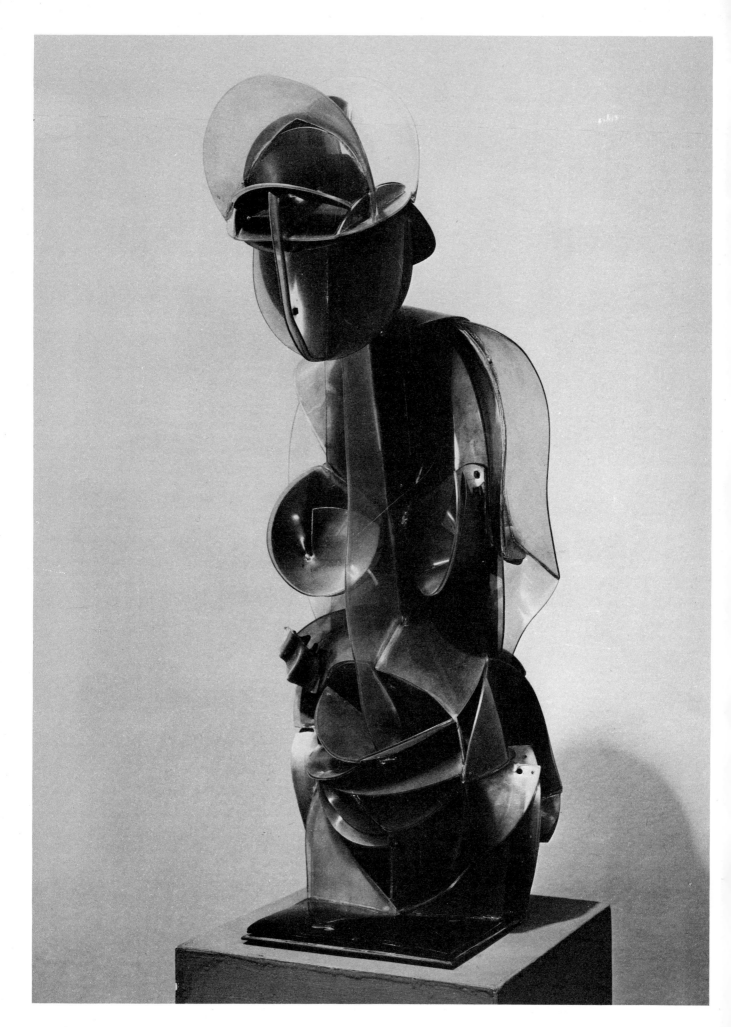

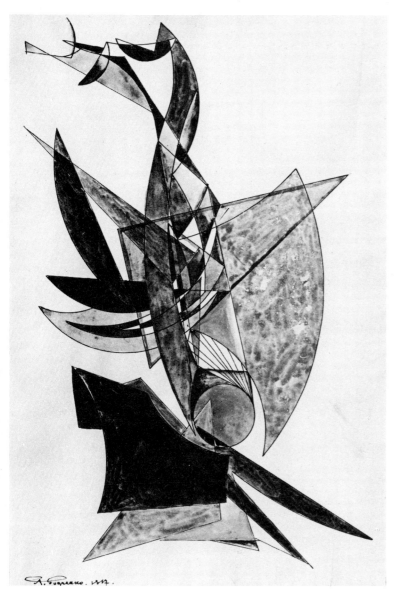

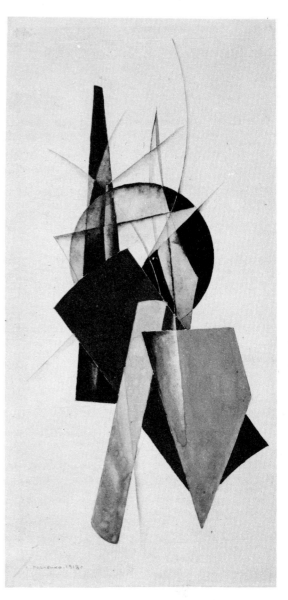

(above left)
35 Alexander RODCHENKO
Composition
LONDON, Annely Juda Fine Art. 1917. Gouache on paper 28 × 19 cm.

Composition was one of a long series of gouache studies by Rodchenko in which he began his examination of pictorial construction by restricting his painterliness to the colouring process whilst drawing with a compass and ruler.

(above right)
36 Alexander RODCHENKO
Composition
NEW YORK, Museum of Modern Art (gift of the artist). 1918. Gouache on paper 33 × 15 cm.

Rodchenko took every opportunity to minimize the painter's traditionally sensuous handling of his materials. Compass and ruler were used to play down suggestions of self-expression, so that his painting might be constructed from commonly applicable and commonly available elements.

(opposite)
34 Anton PEVSNER
Torso
NEW YORK, Museum of Modern Art (bequest of Katherine S. Dreier). 1924–26. Copper and plastic 73·7 cm. high.

Despite the modernity of plastic, Pevsner's figure recalls in its proportions the sculpture of classical antiquity, whilst the severely stylized head is reminiscent of the forms of African sculpture. Pevsner's sculpture is constructed, but is the antithesis in its aims of the Constructivism of Rodchenko and his colleagues.

opposed to painted forms, and closer, therefore, to Tatlin's culture of materials (Plate IV, see page 36).

In many ways, much of the non-objective art of the early 1920s can be seen as stemming from the pioneering work of Malevich in two dimensions, from Tatlin in three dimensions and from the impact of their innovations on younger artists through their friendship, teaching and exhibitions. The circle of artists which formed around Malevich at Vitebsk included Klutsis, Puni, Lissitzky, Chashnik and Suetin and operated in the field of design under the name of *Unovis* (Plate 18).

In Moscow, at the former College of Painting, Sculpture and Architecture, which together with the Stroganov College of Applied Art had been formed in 1919 into the new Higher Artistic and Technical Studios (*Vkhutemas*), the influences of Tatlin and Malevich were strongly felt. In this college a great variety of artistic attitudes were represented, non-objective art being only one of many factions. Unlike the Bauhaus school set up in Weimar in 1919, a union of a fine art academy and an arts and crafts school, the Moscow *Vkhutemas* was not moulded to a particular theory of art, design or teaching. It was far more a melting pot of views and an arena for the conflict of opinions. Nevertheless, it came to have a strong non-objective corpus comprised of Constructivists grouped around Alexander Rodchenko and Alexander Vesnin who formulated an increasingly materialist view of construction as basic creative work and who moved into design work. They eventually abandoned altogether the investigation of artistic creativity as such. Other factions were broadly devoted to investigating the psychological and aesthetic impact of forms, colours and lines. Even within the non-representational field, artists such as Gabo, Lissitzky and, in architectural studies, Nikolai Ladovsky were actively at odds with committed Constructivist theory and teaching.

A second body for the study of creative work was established in Moscow in 1920, the Institute of Artistic Culture (*Inkhuk*). The painter Kandinsky was its first president and its active members included Malevich, Tatlin and Rodchenko as well as Constructivist artists, amongst them Alexander Vesnin and Lyubov Popova.

Kandinsky's theory of art at the time of his presidency of *Inkhuk* was not incompatible with a basic study of the material means of art, yet in his intense preoccupation with the psychological impact of colour and form, with which he hoped to compose paintings as abstract and ethereally intangible as music, Kandinksy came into conflict with those who worked within the new 'culture of materials' handed down by Tatlin to his younger followers. Kandinsky's own creative theories were to reach fruition in his writing and teaching at the Bauhaus in Germany, to which he subsequently moved at the invitation of its director, Walter Gropius. After his departure, a more decisively Constructivist bias developed within *Inkhuk*.

Under its Constructivist leadership, *Inkhuk* organized two exhibitions which lucidly illustrated the evolution in Constructivist thinking. These exhibitions were those of *Obmokhu* (Union of Young Artists) held in Moscow in May 1921, which was an exhibition of two-dimensional and three-dimensional constructions, and the exhibition $5 \times 5 = 25$ held in Moscow in September 1921.

Obmokhu was in fact the third exhibition by the artists' group of the same name and included works by Alexander Rodchenko together with his pupils and Constructivist associates Kazimir Medunetsky, Georgiy and Vladimir Stenberg and V. Ioganson (Plate 39).

In the works of this exhibition it is possible to trace the influence of both aspects of construction in Tatlin's work. The first had its origins in the study of materials and the second arose out of a study of the structural properties of geometric forms. The multi-media constructions by Medunetsky and Vladimir Stenberg suggest attitudes to construction comparable with those of Tatlin and his pupil Lev Bruni in their work with found materials, which survived relatively unaltered in the finished work. The Medunetsky work, now at Yale University Art Gallery, comprises pieces of

(opposite)

III Alexander RODCHENKO
Circular Forms
GERMANY, private collection. 1917. Gouache on paper 21 × 29·5 cm.

The first year after the Russian Revolution was, for Rodchenko, a period less concerned with the design of public fêtes and spectacular displays than with the exploration of pictorial construction. During this fruitful period he moved decisively away from the Suprematists' use of geometrical forms floating in a suggested white space. Rodchenko had begun to undermine the opposition of foreground and background which was conventional in the presentation of an image and in the development of pictorial space, even in Suprematist painting. Rodchenko's gouaches of 1917 reveal the beginning of this process. In *Circular Forms* a near-vertical straight line is shaded at each end as if its white surround were solid; this device is repeated with the crescent. The shapes defined by Rodchenko's ruler and compass are made concave to suggest a positive form in the surrounding whiteness, so that background and foreground are engaged in an interplay, shortly to usurp completely the pictorial space of Suprematism. This was to lead Rodchenko step by step into an investigation of pictorial construction, in which the relation of image to background was superseded by the pictorial means of Constructivism, and eventually to the abandonment of painting.

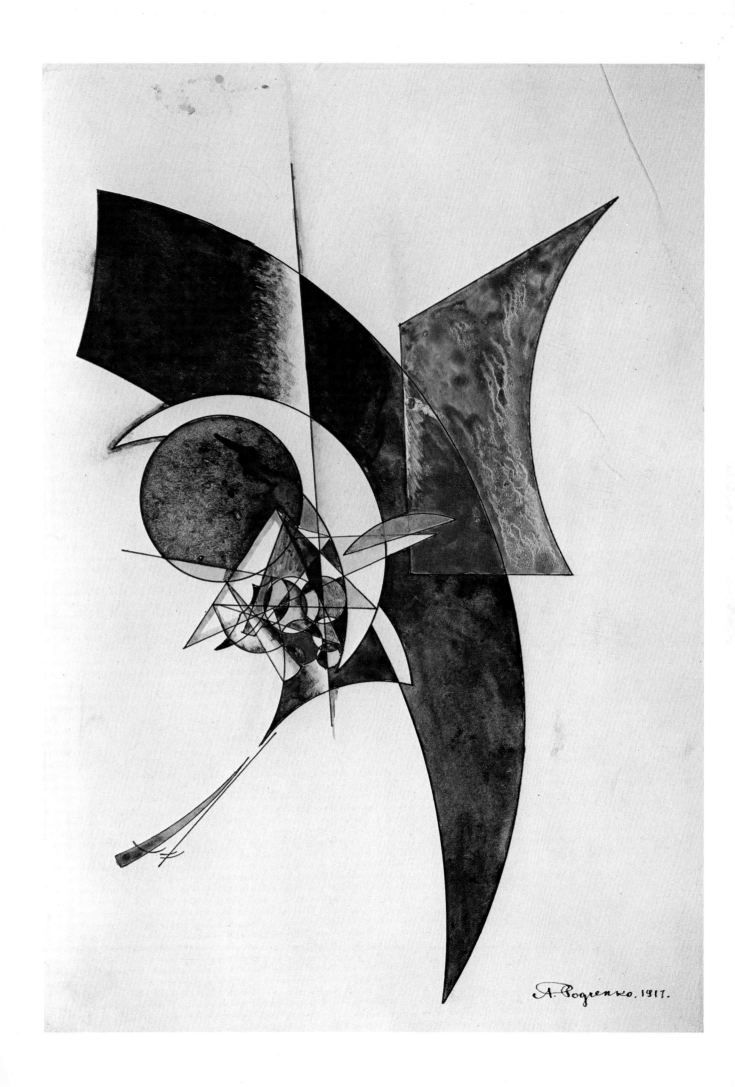

A. Rodchenko. 1917.

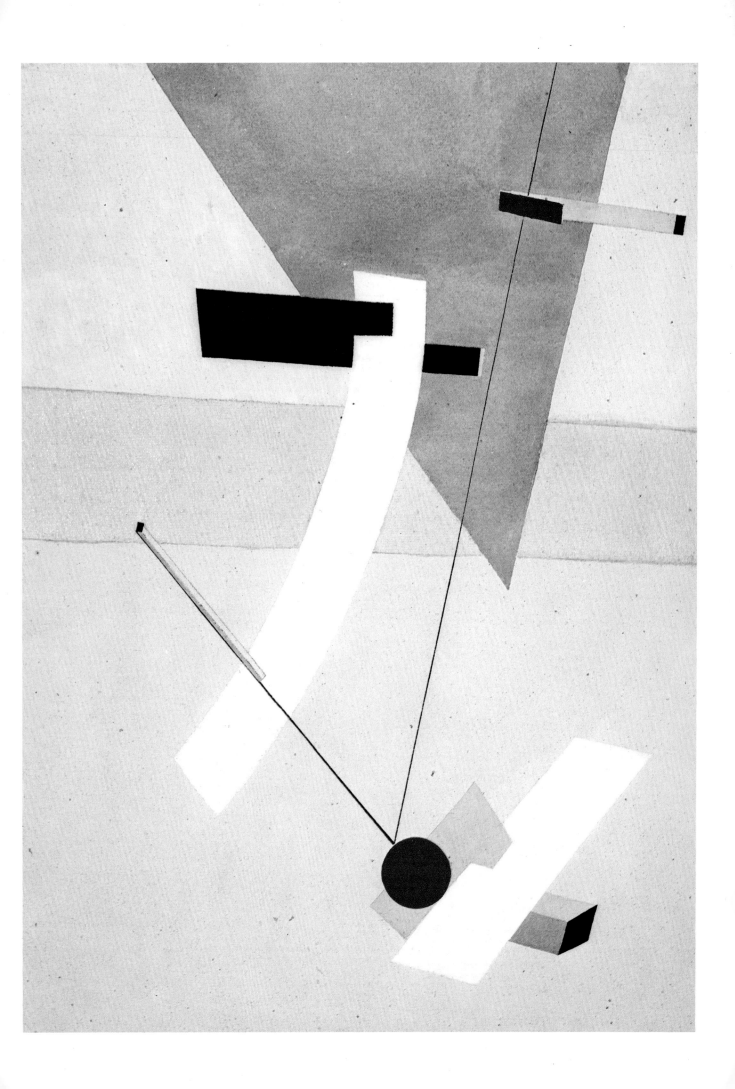

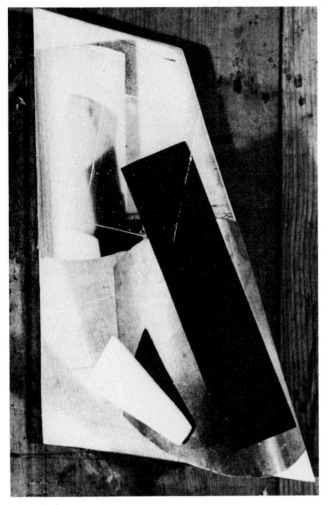

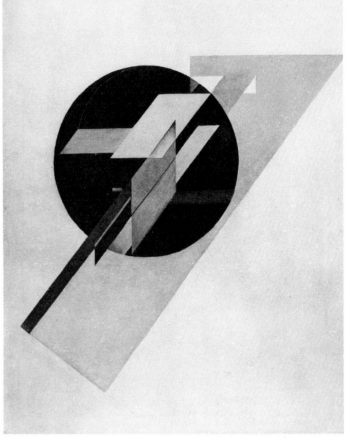

(*above left*)
37 Ivan PUNI (POUGNY)
Systematic Construction
GERMANY, private collection. 1916. Wood, metal and glass 36·5×23·5 cm.

Puni devised a pictorial construction, as had Altman, Tatlin and others, in which the textures and other material qualities, namely shine, rigidity, flexibility and transparency, of the elements of the relief are of greater importance than their colour. In the relief Puni relinquished illusionistic picture space, which would appear to recede behind the picture surface, for the actual space in front of the board.

(*above right*)
38 Gustav KLUTSIS
Composition
LONDON, Annely Juda Fine Art. c. 1920. Oil on canvas 66×47·5 cm.

The Suprematist flavour of Klutsis's early works is clear in this painting, although it already suggests a sense of construction in space which appears to flow and circulate between the painted forms. If the painting is read as an axionometric production, the sense of construction is emphasized. It is closer to the work of Lissitzky than to that of Malevich.

(*opposite*)
IV El LISSITZKY
Proun 12E
CAMBRIDGE (MASSACHUSETTS), Harvard University, Busch-Reisinger Museum. c. 1920. Oil on canvas 57·1×42·7 cm.

Certain aspects of Lissitzky's work resembled that of both Malevich and Constructivist painters, for whilst he employed the clear and firm geometrical forms of Malevich, he also distributed them in his paintings and prints as if they were elements within complex structures. His viewpoint was ultimately closer to that held by Malevich than to Constructivism, for he remained an artist, articulating the illusions of solid forms in a receding, but equally illusionistic, picture-space. None of his love of the engineer's precision, of the architect's approach to geometrical form or of social commitment could change this. It distinguished his position clearly from the Constructivists' preoccupation with such factual and material qualities as the handling of physical components and the undermining of pictorial recession. Lissitzky, like Altman, Rodchenko, Popova and others, owed much to the example of Malevich, although he evolved an individual method of composition that was of great elegance and vitality and which paid lip service to the forms, if not the ideals, of Constructivism.

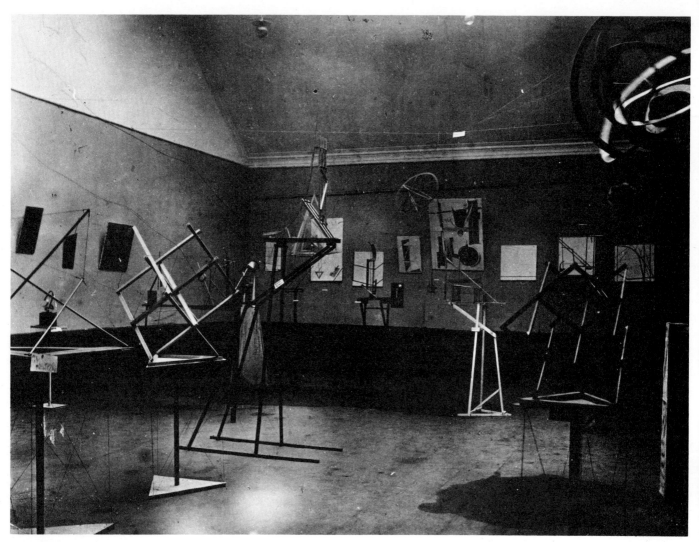

39 *The 'Obmokhu' Exhibition*
1921. Photograph.

This is a general view of the exhibition which took place in Moscow in May 1921. The hanging
works are by Rodchenko; those on triangular bases, except the white ones, are by Ioganson; the tall
standing works are by Vladimir Stenberg and mixed media works are by Kazimir Medunetsky,
Georgiy Stenberg and others.

metal each from some utilitarian object (Plates 40 and 41). The works by the Stenberg brothers are more subtle. They bring diversity and a sense of inventive control to constructions from intractable pieces of glass, wire and steel. As in Tatlin's reliefs the joints and means of construction are lucidly revealed (Plate 42). The means employed to hold the wire, steel and glass pieces together are real, rather than pictorial and revealed, rather than hidden. Unlike Tatlin's works these are free-standing pieces and they have abandoned the pictorial references which so many of Tatlin's reliefs maintained.

Just as Tatlin made clear the means of support employed in his reliefs, in works by the Stenberg brothers a comparably explicit clarity is employed in designing the bases of the constructions, so that these form an integral part of the sculpture (Plates 43–45). A base for a sculpture performs a rôle somewhat like that of a frame around a painting; it not only protects the work but forms a psychological barrier between the artificial world of the art-work and the physical world which supports it. Medunetsky's work has a base which forms just such a barrier, whilst the bases of the pieces by the Stenberg brothers form an integral part of the sculpture and act as a more articulate link with the non-art world of the room's own physical existence and that of objects within it. They are an elaborate investigation of the transitional area between the artificial world of art governed by aesthetic criteria and the less elevated world of physical criteria. For a Constructivist, this area was, at least in theory, of vital importance, as it was here that he could isolate the problem of how far an art-work is necessarily separate or aloof in some way from the world of mundane objects. Conversely, an opportunity to minimize that separation was offered at *Obmokhu*.

The *Obmokhu* exhibition showed one aspect of Constructivism at the moment of its simultaneous perfection and its self-eclipse. It was a final theoretical and practical investigation in Russia of construction as

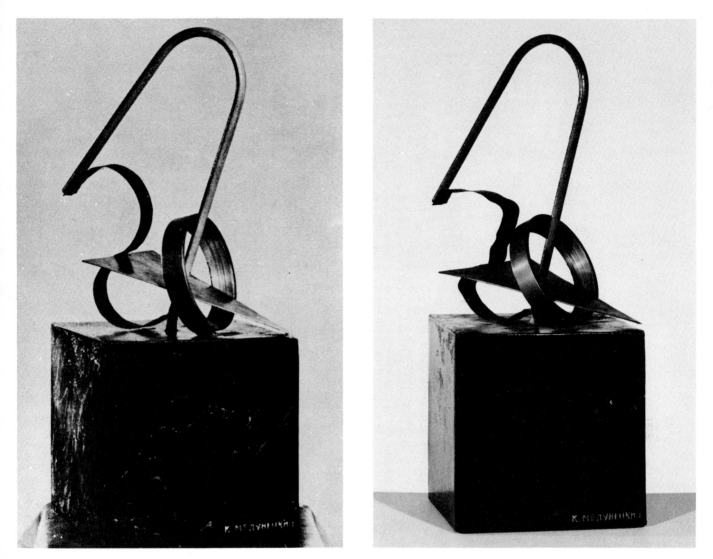

(above left)
40 Kazimir MEDUNETSKY
Construction No. 557
1919. Tin, brass and iron 64·8 cm. high, including base 27·3 cm. high. Documentary photograph.

The original state of *Construction No. 557*, which was exhibited at the All-Russian Exhibition in
Berlin in 1922, is depicted in this documentary photograph. This work is visible in the general view
of the *Obmokhu* exhibition (Plate 39) to the far left of the photograph, in the background.

(above right)
41 Kazimir MEDUNETSKY
Construction No. 557
NEW HAVEN, Yale University Art Gallery (gift of the Société Anonyme). 1919. Tin, brass and iron
64·8 cm. high, including base 27·3 cm. high.

This is the present state of the work.

a creative activity employed in the investigation of, and making of, art-works. The investigation was not subject to social or functional requirements, such as the embodiment of an ideological principle or the presentation of information. In this sense it represents an extreme position of Constructivist work and one which was not repeated.

The works exhibited by Rodchenko at the exhibition displayed other aspects of this extreme position. If an aesthetic assessment is permissible in this context, the Constructivists appear to have taken the small step required to move completely away from aesthetic delectation towards an objective, and more mathemat-

ical, analysis of construction, one in which the personal hand of the constructor no longer necessarily played a part and in which the object made became relatively independent of particular materials and altogether more diagrammatic. Rodchenko was the key figure and the only precedent for his works lies in Tatlin's *Tower* (Plate 25), with its double spiral, although the problems of reconstructing this work appear to reveal it as more intuitive in form than one might expect from the look of it. The works exhibited by Rodchenko at *Obmokhu* were hanging sculptures based upon the elementary geometric forms of the circle, triangle, hexagon and ellipse (Plates 46 and 47). Once Rod-

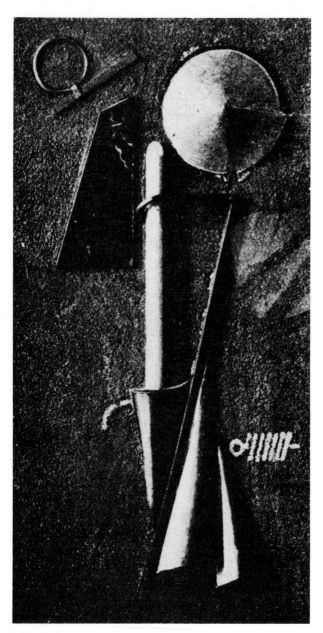 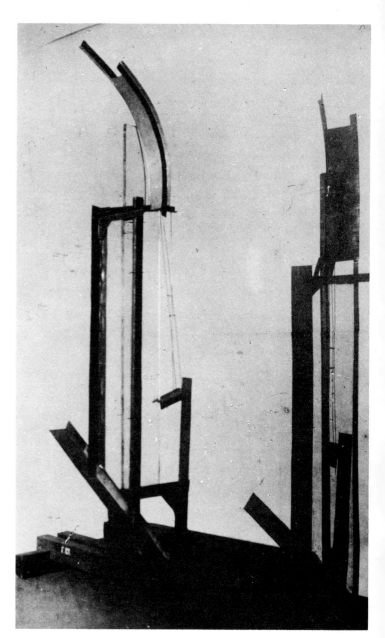

(above left)
42 Georgiy STENBERG
Relief
Whereabouts unknown. Mixed media. Documentary photograph.

Relief was exhibited at the *Obmokhu* exhibition in 1921 and is visible in the general view (Plate 39), slightly to the left of centre on the far wall. It apparently makes use of found elements.

(above right)
43 Georgiy STENBERG
Construction in Space
Whereabouts unknown. Iron, wood and glass 81·2 × 27·5 × 41·1 cm. Documentary photograph.

The work was exhibited at *Obmokhu* in Moscow in 1921. It stands on a complex base and is visible at the centre of the general view of the exhibition (Plate 39). Its construction appears to be closely related to the demands of the material, yet it is still self-contained and has no evident functional application.

chenko had defined the process and its starting point, these constructions followed logically. In a sense, the construction resembles a theorem in that it is independent of specific physical scale or material, for any actual physical work based on that idea is merely an example or an illustration of the concept. Within practical limits the particular material and scale may vary. Gabo later approached this position with his *Spheric Theme*. Conversely, to seek the stylistic contribution of its maker in such a work is evidently no longer a relevant exercise. Rodchenko, the constructor, has successfully jettisoned those fine art considerations. His constructions could in theory be published in kits without any loss or gain in originality to the idea, for it is the idea which has become the basic material of construction. Rodchenko's contributions to Construc-

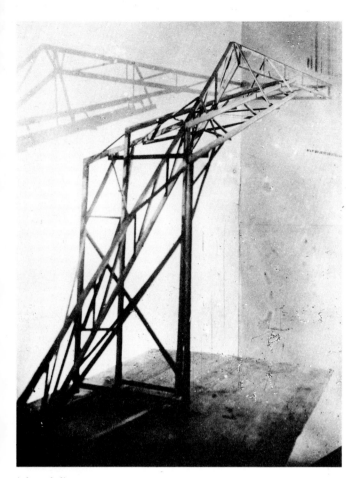

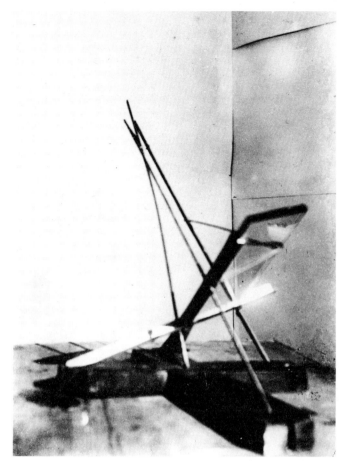

(above left)
44 Vladimir STENBERG
Construction in Space
Whereabouts unknown. c. 1921. Iron 74·7 × 27·5 × 153·4 cm. Documentary photograph.

Construction in Space is related to those works by the Stenberg brothers exhibited at *Obmokhu* in May 1921, some of which were also previously shown in January 1921.

(above right)
45 Georgiy STENBERG
Construction in Materials on a Cruciform Base
Whereabouts unknown. c. 1920. Wood, glass, metal rod, wire and angle-rod. Documentary photograph.

A free-standing study in material construction, to which a dynamic structure is given by the leaning diagonal of the wire rods trapped in the base and supporting in turn the angle-irons and piece of glass, this *Construction* is attributed here to Georgiy Stenberg on the basis of a comparison with *Construction in Space* (Plate 43), which it resembles.

tivism at this time was quite distinct from the culture of materials. In painting these works, Rodchenko contradicted the concept of truth to materials inherent in earlier investigations into the culture of materials.

The form of each of this series was that permitted by the folding of concentric shapes through each other. With each shape a different construction emerges. The *Squares within a Square* (Plate 48) is amongst the most dramatic. Each of these works has a nestling or unfolding quality and all but the ellipse have a centre of gravity below the geometric centre of the largest and outermost piece. Ironically, their visual effect is ravishing, particularly in the instance of the ellipse-within-an-ellipse in which the symmetrical convolution of shell spirals follows the surfaces established by the edges of the elliptical hoops of wood. The fact that

each of the works was cut from concentric forms gives the final structure a centre of origin. In permitting his forms to relate to an origin or kernel in this way, Rodchenko approached Gabo's stereometric space and that sense of ever-expanding space which Rietveld and Mondrian were to define further West. Conversely, the spirals inherent in the elliptical work and its regular skeletal structure recall Tatlin's *Tower*. This, too, had been a potent image of growth. For all its mechanistic qualities, it was a great screw-thread of human endeavour into the future and, simultaneously, an organic structure containing cells, like a thrusting plant stem. Gabo's constructions, too, employed symmetries comparable with natural structures in crystals, snowflakes and plants.

Both Tatlin's *Tower* and Rodchenko's hanging work

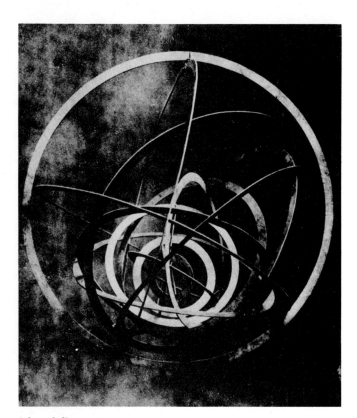
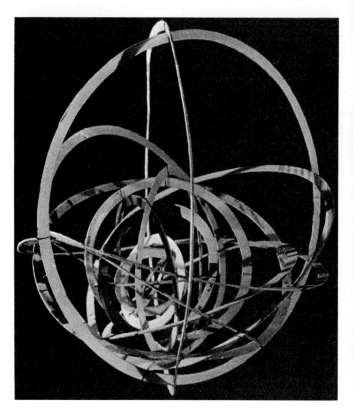

(*above left*)
46 Alexander RODCHENKO
Circles within a Circle
Whereabouts unknown. 1920. Painted wood. Documentary photograph.

Circles within a Circle came from the series *Surfaces Reflecting the Light*. Several works from this series were exhibited at the *Obmokhu* exhibition in 1921. This work is visible top right (Plate 39). Beneath it hangs a hexagonal variation, whilst left and right of centre in the photograph hang the triangular and elliptical variations. The circles were cut from a single sheet of wood and painted to reflect the light.

(*above right*)
47 Alexander RODCHENKO
Circles within a Circle
Whereabouts of the original unknown. Reconstruction, Moscow, private collection. Painted wood.

were kinetic. Movement and flexibility preoccupied many Constructivists, but not solely from a mechanistic viewpoint. Rodchenko saw his mobiles as constructions in light and painted some of them silver to reflect the light and provide maximum contrasts of tone (Plates 47 and 48). They moved, but did so discreetly and without noise from engines or from electric motors. Earlier kinetic works by Rodchenko had involved movement in quite a different sense, but one equally removed from mechanization: these were re-arrangeable sculptures consisting of interslotting pieces (Plates 49 and 50). Rodchenko did not show these at the *Obmokhu* exhibition, but his fellow Constructivist V. Ioganson did exhibit re-arrangeable non-mechanized pieces in a series of mathematically based works constructed from stiff metal rods and flexible wires which maintained physical equilibrium even when adjusted and re-arranged by the spectator.

Both elements, the involvement of the spectator, which lowered barriers between art and life, and the exclusion of personal expression in the execution of the work, even to the point where the work could be readily repeated or reconstructed by a constructor other than the originator, highlighted the Constructivists' avowed abandonment of artistic self-expression in favour of construction. Successful attempts were being made in Russia to undermine the aloofness and artificiality of the artist's creative world, to remove art from its celebrated ivory tower and to divert its energies from personal expression to public expression, to make of art constructive work. Composition, which proceeded by aesthetic criteria and the criteria of personal expression, was giving way to construction, which proceeded by physical and geometrical criteria. 'From this day forward,' Mayakovsky had written in 1917, 'with the abolition of Tsardom, the domicile of art in those closets and sheds of human genius—palaces, galleries, salons, libraries, theatres—is abrogated.'

The *Obmokhu* exhibition had highlighted and examined several critical problems at the heart of the culture of materials. It continued the tradition of Malevich with his *Black Square*, for it had provoked questions relating not to the aesthetic qualities of a particular work, but to the identity and rôle of creative work itself

in contemporary culture. Thus *Obmokhu* was at once a high-point and an ending within the evolution of the Constructivist theory of creative activity.

The very mention of the word 'culture' instead of 'art' at once implies a consciousness of the social rôle of the creative person of which the Constructivists were acutely aware. Their awareness was to alter the development of Constructivism at this moment and to lift it away from the arena of fine art altogether towards a commitment to abandon art and, if possible, to annihilate it. What was to replace it was politically and socially committed design, the construction not of small assemblages of different materials, but of steps towards, and objects for, the new state.

Before this position was fully formulated, however, a second exhibition that was to have crucial implications for the Constructivists was held in Moscow in September 1921. The title of this exhibition, $5 \times 5 = 25$, underlined its basic mathematical bias. It also referred to the fact that five Constructivists each contributed five works to the exhibition, which was probably the last exhibition of Constructivist art (Plate 53). Like *Obmokhu* it represented, at least in the case of Rodchenko's work, one of the critical high points and turning points of Constructivism. The contributors to $5 \times 5 = 25$ were the women painters Alexandra Exter, Lyubov Popova and Rodchenko's wife Varvara Stepanova, who exhibited under the name Varst, as well as two men, the painter and stage designer Alexander Vesnin and Alexander Rodchenko. Exter and Popova were painters of strong, vigorous and colourful canvases which, for all the toughness of their pictorial construction, exuded impressive vitality (Plate 54). They added all the richness of colour which Malevich had begun to permit himself to the grating clarity and firmness of construction demanded by Constructivism.

Theoretically, pictorial construction was perfectly conceivable in Constructivist terms, although illusion of any kind, or any hint of it, was necessarily expunged and an emphasis upon the psychological impact of colour and line was equally impermissible. What remained constituted a critical pivot for Constructivism. To construct, rather than to compose, a painting meant to use lines and forms across non-recessive two-dimensional space and to discover the constructive possibilities of the material to hand, seen either as being line, shape and colour, or as gouache or oil paint on board or canvas (Plates V and VI, see pages 53 and 54). Evidently the Constructivists would not have considered their paintings as abstract, but, instead, as self-contained concrete constructions of material, in this case comprising lines, colours and shapes (Plate 55). It was the actual, not the suggestive, qualities of lines and colours which were important (Plate 56). It is not surprising that Kandinksy left *Inkhuk*, which embodied the antithesis of his own view, in which the spiritual or psychological potency of colour and line were used to

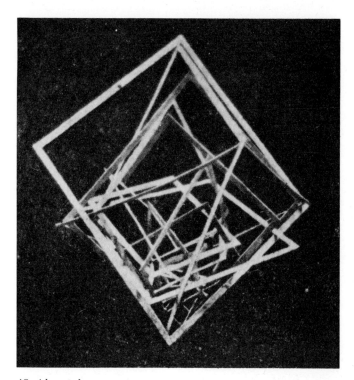

48 Alexander RODCHENKO
Squares within a Square
Whereabouts unknown. c. 1920. Painted wood. Documentary photograph.

Also from the series *Surfaces Reflecting the Light* (Plate 46), *Squares within a Square* is comparable with works exhibited at *Obmokhu* in 1921. It was reproduced in the journal *Kinofot* and its crystalline structure was the most dramatic of the series.

express the soul and its sensations.

It followed that a linear construction necessarily preserved the integrity of its parts. Each line was revealed as clearly and separately as possible, as in the linking of units in reliefs by Tatlin and free-standing constructions by Georgiy or Vladimir Stenberg. Rodchenko's drawing in the Tretyakov Gallery reveals this clearly (Plate 57), as do his drawings for the catalogue of $5 \times 5 = 25$.

A curious conflict of techniques occurred when, given this definition of a drawing as a two-dimensional construction, Rodchenko committed to paper a design for a gigantic building (Plates 58 and 59). The thrusting linear tower is close to one of his linear constructions on paper and is represented in overtly two-dimensional Constructivist terms. The result is hardly functional in appearance.

If Rodchenko's works for the $5 \times 5 = 25$ catalogue, his drawings and paintings from the period 1920–21, are perhaps the most careful and doctrinaire expressions of Constructivist work in two dimensions, then they contrast sharply with the works which are known to be of this period by Lyubov Popova. Her works are full of strength and energy, and are amongst the most vital and vigorous paintings to have emerged not only from Constructivism, but also from this prolific period of Russian art. The dynamic diagonals of her paintings,

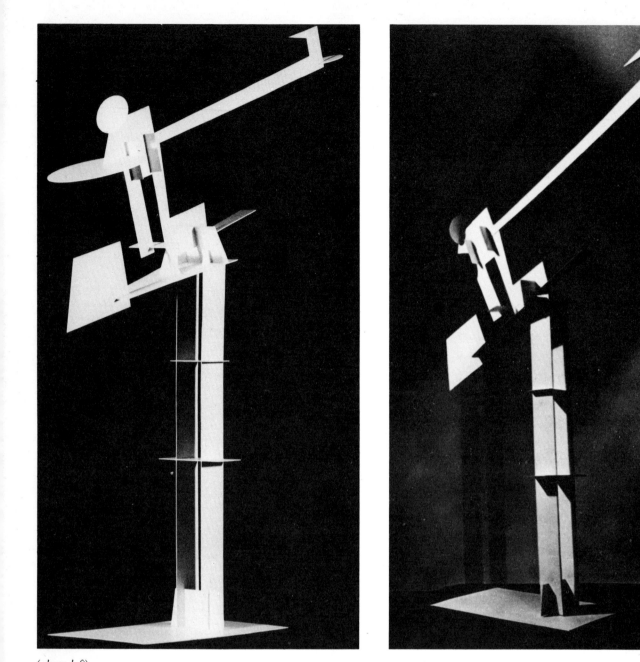

(*above left*)
49 Alexander RODCHENKO
Room Construction No. 6
Whereabouts of the original unknown. Reconstruction, Cologne, Galerie Gmurzynska. 1918.
Painted aluminium.

Rodchenko's work belonged to the series *Connected and Disconnected*. The structure employed in these works is as clear as it is complex. The means of construction are lucidly displayed and become an integral part of the work. At times they add rigidity and, at others, provide an elaborate and adjustable counter-balancing of weights.

(*above right*)
50 Alexander RODCHENKO
Room Construction No. 6
Whereabouts of the original unknown. Reconstruction, Cologne, Galerie Gmurzynska. 1918.
Painted aluminium.

Another view of a reconstruction of Rodchenko's work shows its dramatic cantilevers and the complex interplay of light and shade in relation to the structure of the piece.

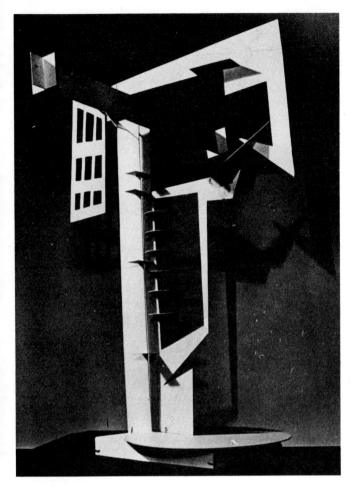

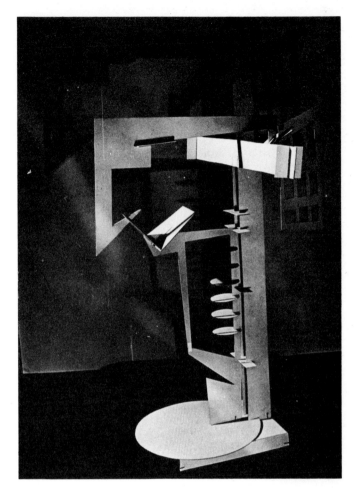

(above left)
51 Alexander RODCHENKO
Room Construction No. 5
1918. Painted aluminium.

Room Construction No. 5 also comes from the series *Connected and Disconnected.*

(above right) ·
52 Alexander RODCHENKO
Room Construction No. 5
1918. Painted aluminium.

Rodchenko's constructions of 1918 were intricate and unprecedented, with elaborate systems of support and counter-balance built into them. The 'window' motif in this work implies a perspective recession which the construction contradicts, for it is not parallel to the wide strut that passes through the top of the work, but is perpendicular to it and parallel to the topmost strut.

and even of her most minimal drawings of the period, are impressive by the unpretentious force of the creative work behind them. They contrast sharply with the slower tempo and poise of Rodchenko's drawings of this time.

As Constructivist sculpture had attempted to lower barriers between the constructed object and the observer, so Constructivist painting, in avoiding the creation within the picture's rectangle of an illusionistic depth, made the painting into another kind of constructed object comparable with more evidently three-dimensional pieces exhibited at *Obmokhu*. An impressive gesture to discourage the works on the walls from being held in too great an aesthetic esteem was the inclusion in the *5×5=25* catalogue of a small original drawing by each of the contributing artists, so that each buyer of the catalogue acquired a work by Vesnin,

Exter, Popova, Stepanova and Rodchenko with their catalogue. Although these now sell at the London salerooms, the original gesture was a sign of the Constructivists' determination to undermine the preciousness of the art-work and to replace it by the constructed object.

Once paintings were seen as constructed objects and the richness of spatial ambiguity available in illusionistic painting was abandoned, there remained only one reason to employ a pictorial format for Constructivist creative works. Rodchenko made full use of it at *5×5=25*. The fact that a flat rectangular surface marked with coloured paints still so clearly recalled a traditional picture with illusory picture-space, led Rodchenko to execute and exhibit a painting which it was all but impossible to interpret in an illusory way. Its construction appears to have been clearly revealed, but

(*above left*)
53 Alexander RODCHENKO *or* Vavara STEPANOVA
Hand-painted Catalogue Cover for the Exhibition '5 × 5 = 25'
1921. Gouache on paper.

The exhibition took place in September 1921. The exhibitors, Alexander Rodchenko, Varvara Stepanova, Alexandra Exter, Lyubov Popova and Alexander Vesnin, inserted small original works into each catalogue. It is likely that they decorated the catalogue covers, too, with the title of the exhibition.

(*above right*)
54 Lyubov POPOVA
Constructivist Composition
Private collection. 1921. Oil on panel 93 × 61·5 cm.

The work was exhibited at *5 × 5 = 25* in 1921. Popova's contributions to the catalogue of the exhibition were coloured pencil drawings of rigid but dynamic structures comparable to this one.

not in the two-dimensional arena. Instead, Rodchenko made clear its three-dimensional physical structure as paint on a ground by denying the picture surface any image other than that of the colour red spread unremittingly across it. There was no room for illusion. Rodchenko had painted a critical and contradictory work; how similar this must have been to the blankness of the *Black Square* by Malevich, a work which at one and the same time was a painting, being paint on a ground, yet a blank denial of all that illusionistic painting, even including Malevich's floating Suprematist space, had traditionally and even recently employed. If, as a painting, Rodchenko's work was aesthetically boring and unyielding, as a cultural gesture it was crucial as an end in itself in the development of Constructivism. With it he abandoned

the examination of creative work . The painting was a work of anti-art, a cultural gesture which marked a turning point in Constructivist theory and work as well as in Rodchenko's own development. He called this red painting *The Last Painting* and within Constructivist theory it occupied that extreme position effectively and confidently. After it Constructivism's concern with internal pictorial considerations appeared to be, by its own tenets, an artistic activity to be shunned. Constructivism as such had reached a natural end. Its first phase saw Tatlin's pioneering reliefs, and its second saw Tatlin's *Tower* (Plate 25). The evolution of its theory had led to vehement denunciation of aesthetic speculation and self-expression. Both of these phases were largely completed after the exhibitions of 1921. In its third phase Constructivism explored its function as a

55 Alexander RODCHENKO
Untitled
LONDON, Annely Juda Fine Art. c. 1920. Oil on canvas 42·5 × 46·5 cm.

56 Alexander RODCHENKO
Untitled
LONDON, Annely Juda Fine Art. 1920. Oil on card 38·6 × 34·2 cm.

Whilst the forms were still drawn with a compass and ruler, the texture of the paint itself began to contribute as the material of a pictorial construction.

(opposite)
57 Alexander RODCHENKO
Linear Construction
MOSCOW, Tretyakov Gallery. 1921. Coloured pencil and graphite on paper 50 × 32 cm.

49

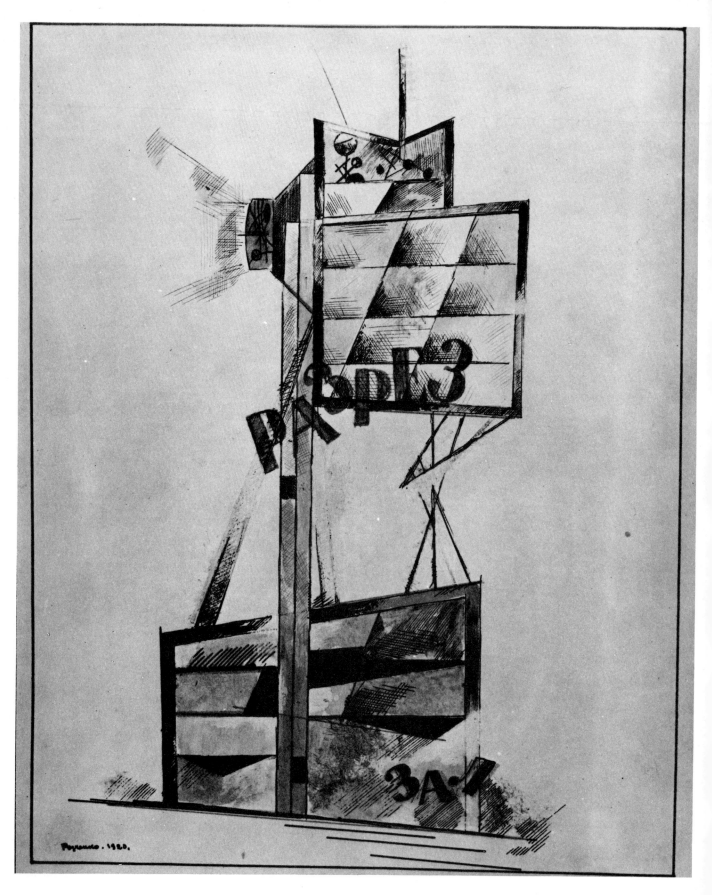

58 (*above*) and 59 (*opposite*)
Alexander RODCHENKO
Project
MOSCOW, Tretyakov Gallery. 1920. Coloured ink on paper 26 × 21 cm.

Rodchenko's *Project* is an elevation and plan for the Soviet Chamber of Representatives ('Sovdep')
1920. Plate 58 is inscribed 'section' (centre) and 'hall' (bottom right). Plate 59 is inscribed 'Plan'
(top) and 'Sovdep' (bottom). An example of a Constructivist architectural project, Rodchenko's

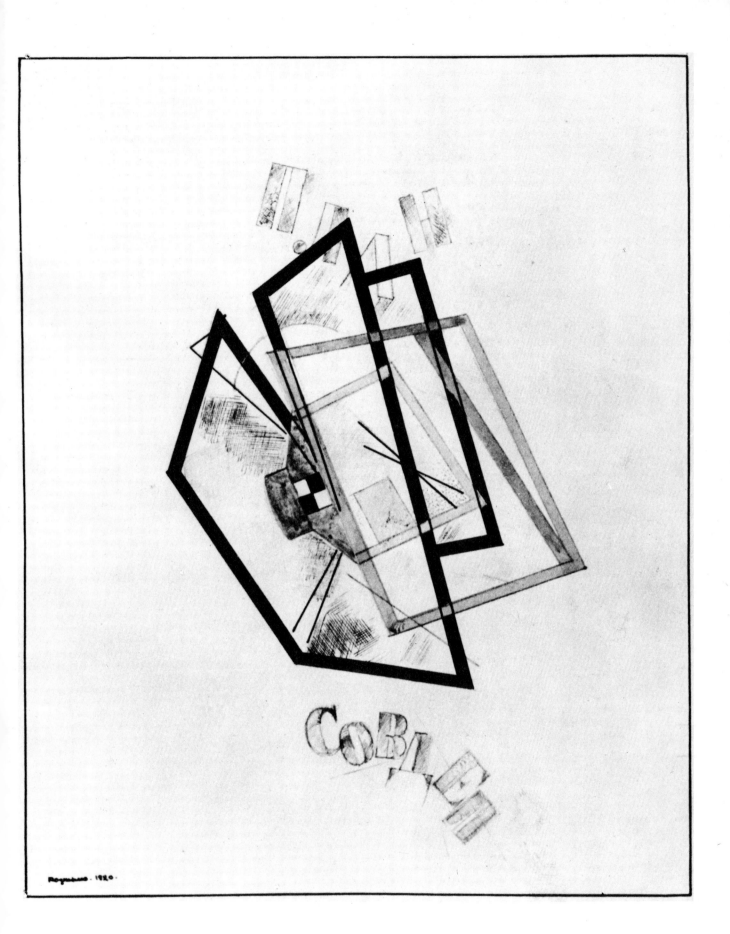

scheme is as much a two-dimensional linear construction as a practical design for a building. The scale was to be enormous. It was designed at a moment when scarcely any buildings at all were put up, consequently it was bound to remain untroubled by the practical problems of its execution.

force in the construction of useful and efficient objects and, on the broader level, its function within the organism of the new society. The inherent laws of Constructivism had been defined by Tatlin, Rodchenko and others in the field of the culture of materials and geometrical construction, without the subjugation of those material considerations to a function imposed from without. In the third phase the basic material for construction was taken to be the new way of life. 'Life-construction' is a word used in the Constructivist theory of the next few years. Constructivists finally abandoned their own ivory towers and turned to the practical design of chairs, clothes and of a whole material cultural framework for daily life. Each object devised was a part of the new life. The Constructivists' formal investigation had been thorough and far-reaching. The new and distinct work which followed was founded upon it. It marked the beginning of the simultaneous spread and dissolution of Constructivist ideals. Those Constructivists who made the change ceased to use the term Constructivist and adopted a new name, that of 'Productivist'. They were still anti-

artists, but they rejected a past identified with the pre-Revolutionary culture. Art, they proclaimed, was dead and indeed, for many of them, it was dead. They turned instead to design and the practical problems of giving form through design to the new culture. This step had arisen naturally out of Constructivism. Rodchenko made the position clear in 1921 when Productivism began:

Construction is a contemporary attempt to organize a *utilitarian* deployment of materials. Constructive life is the art of the future. It is time for art to flow into the organization of life.

In 1922, the theorist Alexei Gan published his book *Constructivism*. In it he reiterates the same principal theme. After 1922 theoretical and experimental Constructivism became committed and practised Productivism. As artistic creativity moved closer to work, the Constructivist became a designer and artisan. 'Art', proclaimed Gan, 'is inextricably linked with theology, metaphysics and mysticism. Down with Art!' This position was more easily maintained by Constructivist theorists than by Constructivist practitioners.

(*opposite*)
V Lyubov POPOVA
Untitled
LONDON, Annely Juda Fine Art. c. 1922. Gouache on cardboard 40·5 × 30 cm.

Popova was a pioneer of great vitality. Her paintings evolved through Cubist and Suprematist phases to dynamic pictorial structures combining energy and directness. Although gouaches of this series continue to suggest a sense of receding picture-space, this is balanced by an alert awareness of the flat surface and a clear revelation of the handling of materials. Thrusting wedges of colour dart across the paper in conflicting directions and over them is laid a network of thick and thin lines that relate both to the edges of the painting and to the earth-coloured wedges within it. The resultant painting is full of implied movement and recession; in this respect it recalls the floating space of Malevich's Suprematism. Popova's use of the picture edge and the degree to which she left evident her handling of paint made these gouaches pioneer works in the development of Constructivism.

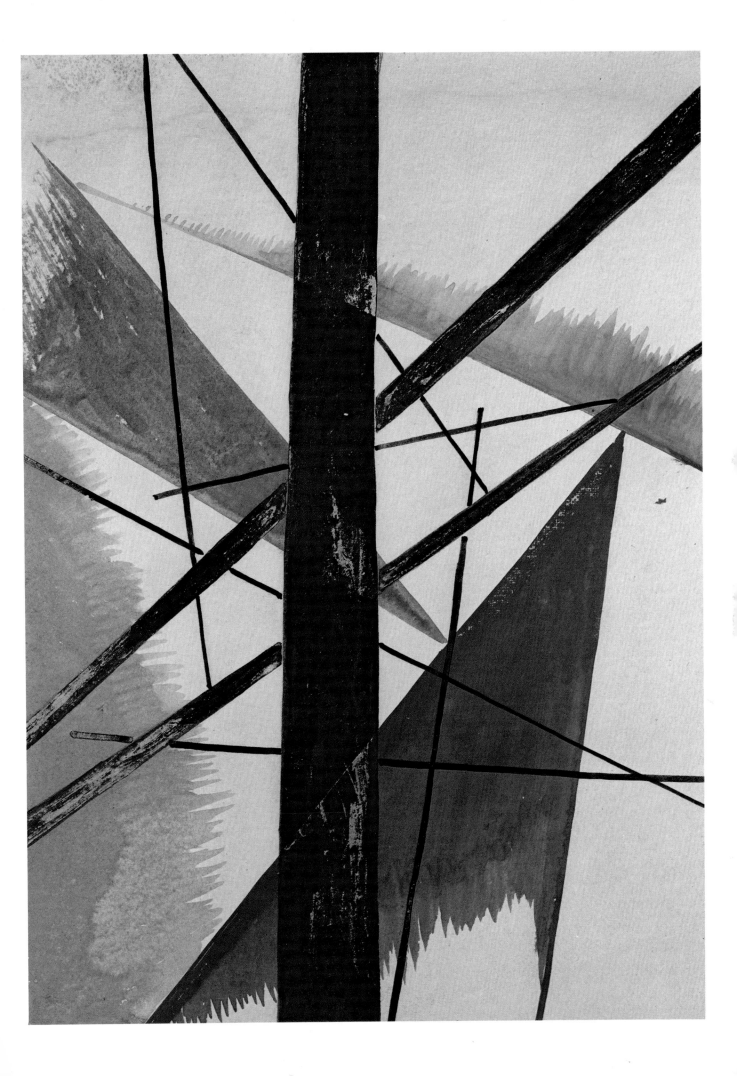

The Rhetoric of Action

THE IMMEDIATELY POST-REVOLUTIONARY years were a time of fierce hardship in Russia. The depredations of the 1914–18 War were superseded first by revolution and subsequently by civil war. Even if the Futurists in Russia had gained some measure of official support, the task before them, which relied upon their social commitment, was insurmountably difficult. Their glittering and utopian view of the future city in the socialist state to come must have provided a very hollow contrast to the emptiness of the streets.

Victor Shklovsky recalled that in autumn 1919:

It was imperative that the streets should not be silent. The shop windows were blank and empty. They should bulge with ideas.

In order to fill empty shops with ideas it was imperative that the Futurists should prove their commitment to the new régime and pull their weight. This they did by propaganda and by practical design (Plates 60 and 61). Architecture was to be financially impossible for some time, but design work did begin and a good deal emerged from the Productivists, especially from *Vkhutemas* in Moscow. Constructivist architecture was almost non-existent in the early years of Soviet society, except as idealistic designs for impossible buildings. Rodchenko's 'Sovdep' *Project* was of this kind (Plates 58 and 59) and Tatlin's *Tower* should be seen in this light.

The designers understood that these projected buildings were impossible to execute, either for financial or structural reasons, or a mixture of both. They were exercises in a kind of utopian rhetoric and their function should be considered more allegorical than structural. They provided an image of a dynamic and effortless future, which was to rise out of the chaotic and war-torn present. The fame and renown which, after half a century, is enjoyed by Tatlin's *Tower* indicates how successful at least one such utopian work was in establishing a dynamic and thrusting image of the new society, all despite the fact that the monument remained unexecuted, that it is known from very few photographs and that not even the pieces in existence are available for inspection.

One answer found to the bare windows of Shklovsky's reminiscence was the production of satirical window posters, called *Rosta* posters, many thousands of which were produced by Mayakovsky almost single-handed, as he provided both the images and the verses to go with them. Often the posters were specifically related to the Civil War and other national events. They retained a freshness through the energy and rapidity of Mayakovsky's work and they operated, in effect, like strip cartoons (Plates 62 and 63).

The work was done on the floor. Mayakovsky made the posters; the others prepared stencils by cutting out cardboard according to a design; still others used the stencils to make copies.
Woroszylski, *The Life of Mayakovsky*, 1972.

Mayakovsky's close companion of these years, Lilya Brik, recalled how:

We worked in an unheated place. The only source of heat to warm the freezing paints and glue was burning newspapers in an old stove.

The public quality of the *Rosta* posters embodied perfectly Mayakovsky's aim for an art of the streets, removed totally from the realms of connoisseur and collector (Plate 64).

Painting as such, which Rodchenko and Tatlin had

(*opposite*)
VI Alexander RODCHENKO
Linear Construction
LONDON, Annely Juda Fine Art. c. 1919. Oil on board 47 × 36·2 cm.

During 1919 Rodchenko evolved the most austere and sophisticated of his linear constructions. In these works Rodchenko avoided the depiction of forms against a background, a pictorial relationship indigenous to representational art and to abstract art. Restricting his means to the use of evenly made straight lines, Rodchenko constructed across the flat surface of his canvas or board. Colour, no longer associated with solid form, inhabited lines which, by their evenness, can be seen at all points to move resolutely across the picture surface. In contrast to this, Rodchenko, with inimitable clarity and decisiveness, constructed from these elements a complex space by means of lines which gained in apparent speed as they converged and simultaneously suggested perspectival recession. This Rodchenko systematically negated by alternative configurations and readings. His *Linear Construction* embodied a spatial complexity which relied, too, upon the construction of planes and surfaces by the repetition of lines. These planes have colour and dimension but no solidity and are not depicted, but constructed.

(above)
60 and 61 Vladimir MAYAKOVSKY
Drawings to Illustrate his Poem 'The Tale of a Deserter Who Turned Out Not Bad Looking and of the Fate Which Befell This Selfish Man and his Family.'
1920–23. Indian ink.

(top right)
62 Vladimir MAYAKOVSKY
Illustration to the Pamphlet 'Down with Home-brewed Drink!'
1923. Indian ink.

(middle right)
63 Vladimir MAYAKOVSKY
Illustration to the Agitpoem by N. N. Aseyev and Mayakovsky 'The Single Master Is Always Poor, Yet It Is Because He Is Poor That He Lives Alone.'
1924. Indian ink.

(right)
64 Vladimir MAYAKOVSKY and Alexander RODCHENKO
Toffee Wrapper for 'Red Army Star Caramels'

The verse reads, 'When there is danger at the front, the red-army soldiers are our defence.' Sweets were made by the Red October State Confectionery Factory in Moscow. Mayakovsky was as willing to abandon the safe and respectable pages of the poetry book as Constructivist artists were to abandon their galleries and museums. Sweet wrappers and state advertisements, printed with couplets by him, helped to make his work more accessible and less aloof.

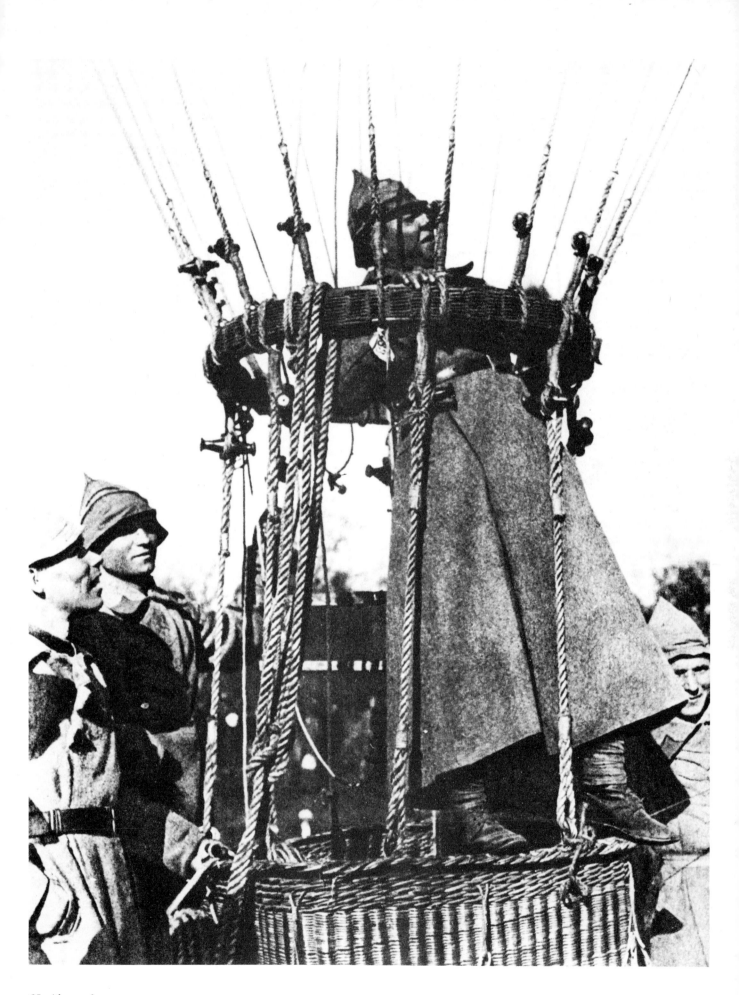

65 Alexander RODCHENKO
Red Army Manoeuvres. Red Army Soldiers in a Balloon
Photograph.

(above left)
66 Alexander VESNIN
Drawing Connected with Costume Designs for Racine's 'Phèdre'

Phèdre was produced by Alexander Taïrov at the Kamerny Theatre in Moscow in 1922. The theatre permitted costumes to take on Suprematist forms and become vital and animated sculptures.

(above right)
67 Alexandra EXTER
Study for Rotating Sculptures
PARIS, Galerie Jean Chauvelin. 1921. Gouache on cardboard 38 × 22·8 cm.

In Taïrov's Kamerny Theatre in Moscow, costumes became sculptural in productions of the early 1920s and stage sets grew closer to kinetic sculptures.

(opposite)
68 Alexandra EXTER
Costume Design
LONDON, Annely Juda Fine Art. c. 1922. Pastel on paper 31·8 × 22·8 cm.

Both Exter and Vesnin worked for the Kamerny Theatre as designers under the directorship of Alexander Taïrov whose productions of the early 1920s employed all the means of theatre to express the mood and atmosphere of a play. Lighting and sets were elaborate and their use minutely controlled. Costumes, too, were intended to contribute to the characterization of their wearers within this framework. They occasionally, as here, incorporated rigid constituent elements of different materials and were not easy to wear.

already undermined in Constructivist circles, naturally continued to exist, but was amongst the art forms least able to adapt to street life. It was slow in execution, still in presentation and unspectacular. It was the public and performing arts that flourished and were best able to accommodate Constructivist and Futurist demands, yet still hold the attention of, and convince, a populace whose interest in the latest and obscurest theories of creativity was probably non-existent. Once former Constructivists actually abandoned, in fact as well as in

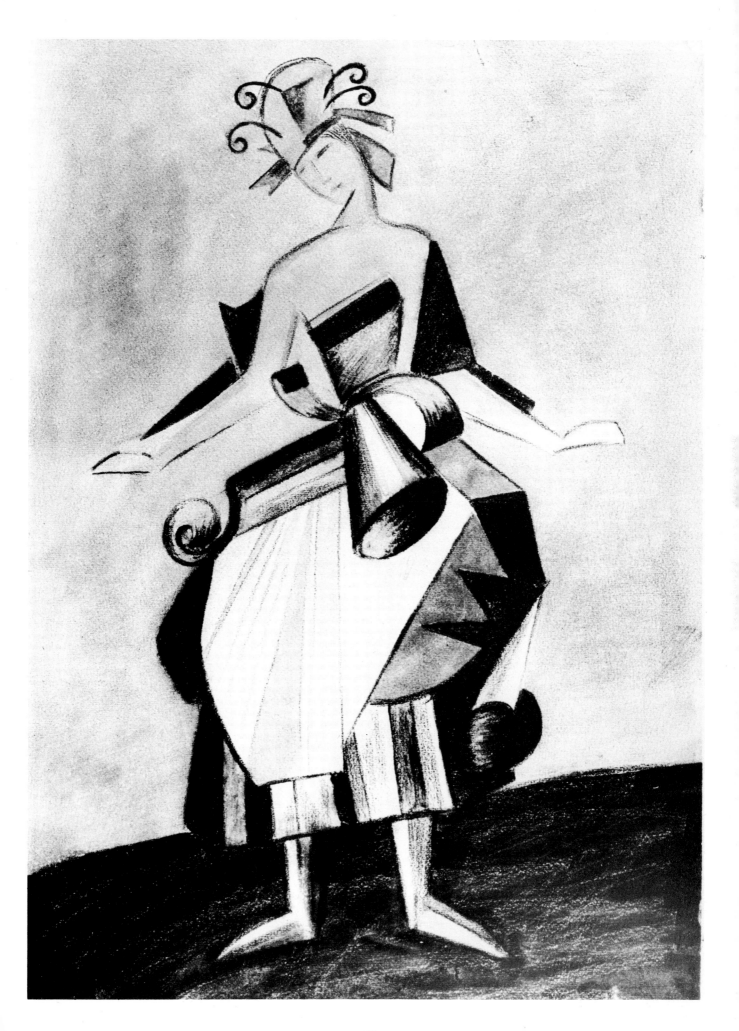

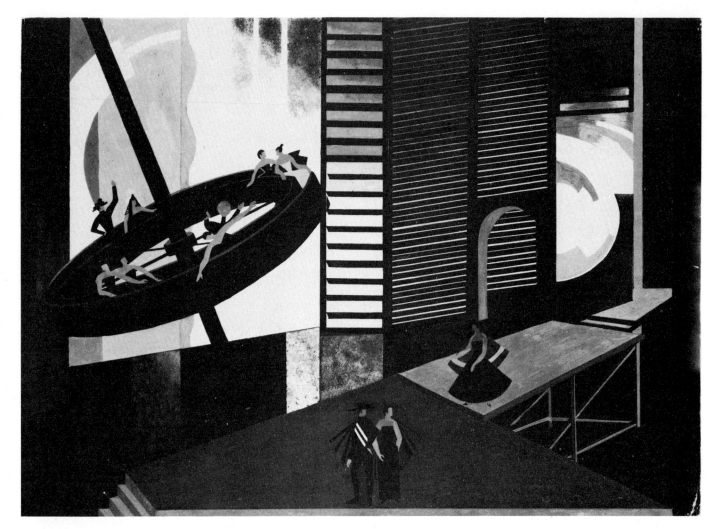

69 Alexandra EXTER
Design for a Stage Set for Calderón's 'La Dama Duende'
LONDON, Victoria and Albert Museum. Body colour on
paper 41 × 67 cm.

Exter's painting, always luxuriously coloured and dy-
namic, found in theatrical design, particularly that for
Alexander Taïrov's Kamerny Theatre in Moscow, a medi-
um which resembled painting in certain respects, yet on
stage permitted her coloured elements to move and
evolve. Calderón's *La Dama Duende* was performed in
Moscow in 1922.

70 Alexandra EXTER
Illustration to 'Notes of a Director'
1921.

Alexander Taïrov's *Notes of a Director* was published in
1921. Exter designed Taïrov's book as well as sets and
costumes. The illustration is inscribed 'scenic atmosphere'
Taïrov employed Exter and Vesnin, but was not himself
a Constructivist director. He did, however, borrow devices
from the director Vsevolod Meyerhold, who was.

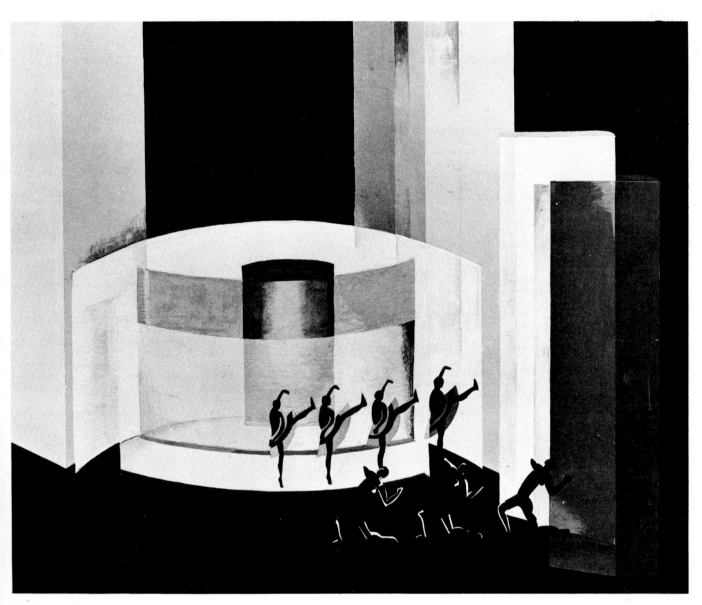

71 Alexandra EXTER
Construction of Light, 1928. Design for a Stage Set
LONDON, Victoria and Albert Museum. 1928. Distemper 46·4 × 56·2 cm.

Exter and Alexander Vesnin both worked for the Kamerny Theatre in Moscow in the 1920s. The director of the theatre, Alexander Taïrov, made use of elaborate changes of lighting to emphasize what he referred to as the 'scenic atmosphere' of the plays he produced. Gestures, movements and costumes were all employed to this end and contributed to the interpretation of the play. Exter became closely involved in these activities which were in the sharpest possible contrast to the productions of the director Vsevolod Meyerhold whose theatre undermined illusion and suggestive devices, abandoned stage lighting and adopted the material views of the Constructivists. In this respect Exter's rôle within Constructivism was equivocal.

principle, their reliance upon studios and exhibition halls and worked in propaganda, in design and for the theatre, their work gained enormously in public accessibility and intelligibility.

The first steps towards the new public arts came with the official celebrations in 1918 of the first anniversary of the October Revolution. Streets and squares were decorated with enormous designs and thousands of people were involved in the immense and symbolic acting out of recent historical events. Apart from the re-enactment of the storming of the Winter Palace, immense allegorical festivals were organized. The theatre director, Vsevolod Meyerhold, planned huge

model cities of the past and future, designed by Constructivists Alexander Vesnin and Lyubov Popova, for the celebration 'Struggle and Victory' which he prepared for the Congress of the Third International. The director, Sergei Radlov, manipulated enormous throngs of troops and civilians in these displays. His first mass play was the *Blockade of Russia*, performed in June 1920 using Petrograd as its setting, in which he employed a battleship, and used his own troupe of performers to act out the individual rôles and a large number of Red Army soldiers as a chorus. Amongst the largest of Radlov's mass-spectacles was *Toward the World Commune* in July 1920, which involved 4000

soldiers and sailors, and lighthouses set up on the river Neva in Petrograd in addition to lights, sirens, blank shots, banners and flags.

Such spectacular mass plays were propaganda exercises which used many of the elements already traced in the work of Mayakovsky, Tatlin and Constructivists around Rodchenko. That general trend in the arts away from representation towards the presentation of facts in which construction, work with physical or factual materials, increasingly replaced composition, aesthetic predilection, found a social equivalent in which thousands of spectators could become participants. Theatre, then film and architecture all employed Constructivist means to make their audience more self-aware as social creatures. Painters and sculptors, whose work was less public than that of theatre directors, film directors or architects, adapted their work as far as possible to public media. In this respect the traditional Russian link between painters and the theatre was vital (Plate VIII, see page 72). Tatlin, Rodchenko, Exter, Popova, Stepanova, Vesnin, Bruni, Medunetsky and the Stenberg brothers, all the central figures of Constructivism, worked in the theatre.

Vesnin and Exter had recently worked at the Kamerny ('Chamber') Theatre in Moscow under the director Alexander Taïrov on a number of productions (Plates 67 and 68) in which the proscenium area of the stage was transformed into a kinetic and dramatic 'painting' in which the real depth of the stage replaced the illusionistic depth of pictorial space (Plate 72). Alexandra Exter's sets and costumes for the 1917 production at Taïrov's Kamerny Theatre of *Salomé* by Oscar Wilde provided an extreme example, followed later by Alexander Vesnin in his designs for Racine's *Phèdre* staged by Taïrov in 1922 (Plate 66). Characteristic of this kind of stage design was the dominance of the overall impact of the play. In Taïrov's theatre a play was in fact a highly aesthetic affair in which the director controlled the mood of his audience by uniting effects of gesture, lighting, dramatic action, costumes and stage sets all together, to express what Taïrov called the 'scenic atmosphere' of the play (Plates 70 and 71). This attitude with its heavy reliance upon aesthetic effect, was the direct heir of the Symbolists and of Wagner. It is surprising that the Constructivists Exter and Vesnin became involved in it, yet it did represent a movement away from the ivory tower of art for art's sake, of painting and sculpture complete in themselves. Gestures were formalized and no more naturalistic than the sets; the director, as overseer of the assemblage and its ultimate creator, was the unifying and dominating influence.

The director who came most closely to adhere to strictly Constructivist principles was Vsevolod Meyerhold. He too rejected the naturalistic stage and the theatre of suspended disbelief, of which the contempo-

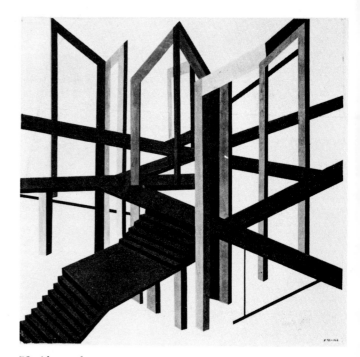

72 Alexandra EXTER
Design for a Constructivist Stage Set.
LONDON, Victoria and Albert Museum. 1924. Gouache 50·8 × 52·7 cm.

All of the strongest adherents to Constructivism turned their hands to theatrical work. Exter shared her activities in this respect with Tatlin, Rodchenko, Popova, Stepanova, Alexander Vesnin, Kazimir Medunetsky and the Stenberg brothers, all of whom contributed to theatrical productions. For Exter this represented an activity close to painting, but for many Constructivists it provided a public extension of their work and an escape from the relatively private world of easel painting.

rary work of the Moscow Art Theatre provided so prominent and successful an example under the directorship of Stanislavsky.

Meyerhold, in certain respects, was the antithesis of Taïrov as a director. Although he shared a belief with Taïrov in the dominance of the director over his actors and designers, Meyerhold was passionately committed to a stage without illusion, in which the action took place without the aid of footlights, which tend to create a separation between the world of the actors, bathed in lights, and that of the audience in semi-darkness. At times Meyerhold set the action in the auditorium, either off-stage or on extensions of the stage, to deny further the 'sacred' and traditional separateness of the stage from the everyday world. This provided a theatrical parallel to Tatlin's counter-reliefs, for the 'make-believe' world of the picture-space or the stage-space had its construction and its supporting paraphernalia revealed; simultaneously the artist, contradicting the aims of traditional perspective, moved decisively forward in space, either off the picture 'surface' or out of the proscenium front, into non-illusionistic physical space shared with the viewer. Certain kinds of theatre had done this traditionally and Meyerhold seized upon their example. The music-hall, for instance, tradition-

73 V. V. LYUTSE
Biomechanical Exercises
1922. Drawing.

'Biomechanics' was the name adopted by the Constructivist theatre director Vsevolod Meyerhold
to describe a system of controlled movement on stage in which the body of the actor was seen in
material rather than expressive terms. Instead of pathetic gestures, athletic performance took place
on the stage which came to resemble a circus arena or music-hall. Rather than using the stage to
create an illusion of another time and place, Meyerhold left it aggressively bare, used no footlights
and provided a minimal set, which often functioned as an acrobatic apparatus.

ally establishes strong links with its audience as does the circus with its central arena for events of a physical nature as close to athletics as to acting. Disbelief is not suspended in the circus as it is in the theatre, the performer is free to approach the audience and can be successful by presenting a feat of balance or daring without ever representing anything.

Meyerhold exploited the brash popularity and directness of the music-hall artist as well as the physical performance of the circus acrobat. On stage, without footlights, on sets more the apparatus for acrobats than reminiscent of other times and places, Meyerhold directed actors whose elasticity was genuinely athletic. For Meyerhold, athletics replaced aesthetics. The actor became a mechanical object whose movements were minutely controlled by Meyerhold according to a system which he called 'Biomechanics' (Plate 73). Biomechanics employed the physical qualities of the actor thus making him or her the material used by the director, in much the same way as the Constructivists Tatlin and the Stenberg brothers had examined the material construction possible with, or natural to, the physical materials of metal, wood and glass.

An article signed by Meyerhold in 1920 stated this link emphatically:

We have only to talk to the latest followers of Picasso and Tatlin to know at once that we are dealing with kindred spirits . . . We are building just as they are building . . . For us the art of manufacturing is more important than any tediously pretty patterns and colours. What do we want with pleasing pictorial effects?

What the *modern* spectator wants is the placard, the juxtaposition of the surfaces and shapes of *tangible materials*.

The Constructivists Vesnin, Popova, Stepanova, Medunetsky and the Stenberg brothers all worked for Meyerhold. The kinetic devices constructed by Popova for Meyerhold's production of Fernand Cromelynck's tragi-farce *The Magnanimous Cuckold* and Stepanova's sets for Sukhovo-Kobylin's satire *Tarelkin's Death* with their slides, chutes and trapdoors were a perfect sculptural counterpart to Meyerhold's athletic biomechanics.

The stage sets had become gymnastic apparatus. Popova's set refers to a windmill in the play's text without giving her audience the slightest opportunity of forgetting that they are actually in a theatre and not by a windmill. The sails and wheels, one of them bearing letters from the author's name, rotate in time with the action of the plot, whirling round fast at excited moments and slowing down at others.

Stepanova's set has collapsing stools and other circus-clown props (Plates 75 and 76). In its construction it makes no attempt to follow that kind of Constructivism which investigates materials. Its mathematical simplicity recalls her husband Rodchenko's hanging mobiles. Individual units of the set are even closer to a set of small constructions devised by Rodchenko in 1921, in which small and often crudely cut units of wood are combined symmetrically in a whole series of basic variations and spatial arrangements. A photograph of Stepanova and her associates (Plate 77) reveals shelves in the background, the lower of which houses models by Stepanova for the sets of *Tarelkin's Death* and the upper houses some of the spatial studies by Rodchenko (Plate 78). The photograph pin-points that moment when Constructivism moved out of the studio and made itself increasingly available to the public media of the poster, book design,

74 Alexandra EXTER
Design for a Costume of a Russian Soldier in 'Tarelkin's Death'
LONDON, Victoria and Albert Museum. 1921. Pencil and
body colour on paper 43·8 × 30·1 cm.

Although 1921 was the year in which painting as such
was abandoned by Rodchenko and other Constructivists,
projects for the theatre and for architecture elicited a
vigorous response to the design of sets and costumes, an
activity which demanded a fresh approach to representa-
tion. *Tarelkin's Death* was performed at the Moscow Art
Theatre in 1922.

(*opposite top*)
75 Vavara STEPANOVA
Set for the Play 'Tarelkin's Death' by Sukhovo-Kobylin
1922. Wood.

(*opposite bottom*)
76 *Vavara Stepanova on her Set for 'Tarelkin's Death'*
Photograph.

Stepanova can be seen inside part of her set which
included shutes, slides, cages and trick chairs. The play,
directed by Vsevolod Meyerhold, opened in Moscow in
November 1922.

exhibition design, theatre, film and architecture. The
Constructivist contribution was considerable in all of
these fields and creative people in many areas began to
respond to Constructivist influence.

In the theatrical sphere, productions by Taïrov in
Moscow and by Diaghilev's Ballets Russes in the West,
responded enthusiastically to the forms of Constructiv-
ism. Taïrov produced G. K. Chesterton's story *The Man
Who Was Thursday* at the Kamerny Theatre in 1922
with intricate re-arrangeable sets by Alexander Vesnin
and Diaghilev produced *La Chatte*, with sculptural sets
by Naum Gabo and his brother Anton Pevsner, in
Paris.

One of the last major works by Popova was also one
of the last of the strut-built constructions used by
Meyerhold of the kind instigated by Popova and
Stepanova in 1922. This was for his production in
March 1923 of Trotsky's *The Earth in Turmoil* (Plate 79).
Her machine was no longer a gymnastic apparatus, but
the same clarity of structure prevailed. As with the
'windmill' of *The Magnanimous Cuckold*, so here the
construction is in a sense representational and consti-
tutes a crane with lifting platform and wheels. It also
carries a screen for the projection of visual material
during the performance (Plate 80). Her photomontage
poster for *The Earth in Turmoil* (Plate 81) depicts
Popova's apparatus clearly and shows the author far
left, with figures whom she disapproved of crossed out,
inverted and being lowered from the crane. The screen
declares: 'We shall build the new world.' The play was

agitational and provocative in character. It employed
an actual lorry on stage and made use of the theatre's
gangways for vehicles and troops.

These sets of 1922 and 1923 constituted kinetic
sculptures in use. They were no longer in themselves the
intensive investigations of structure which 1921 had
witnessed amongst certain Constructivists. They were
now part of a larger whole and the material being
investigated was the material of theatre. A more light-
hearted expression of such a coalition is the film *Aelita*
of 1924, directed by Protozanov, designed by Alexan-
dra Exter, and telling, in illusionistic but extraordinary
terms, of revolution on the planet Mars. Exter's space-
age sets and costumes for the Martian episodes are set in
an enormously complex and entertaining Constructiv-
ist environment (Plates 83–86). The figures themselves,
in plastic, wire and wooden costumes, often with rigid
parts impeding their movements, are made into
moving sculptures. The hinged-wood pantaloons of the
servant, which flex open and shut as she moves, give
more than a hint of the vitality of Constructivist theatre
design (Plates 84 and 86).

But by no means was the vitality of Constructivism
manifested only in the theatre. The dynamism and
tenacity of the Constructivist investigation into the
processes of creative work, with its implication that
culture was no longer aloof, brought, in theory, art and
work closer together. Both were involved in the
construction of the new state. Popova's construction for
The Earth in Turmoil displayed the slogan 'We shall

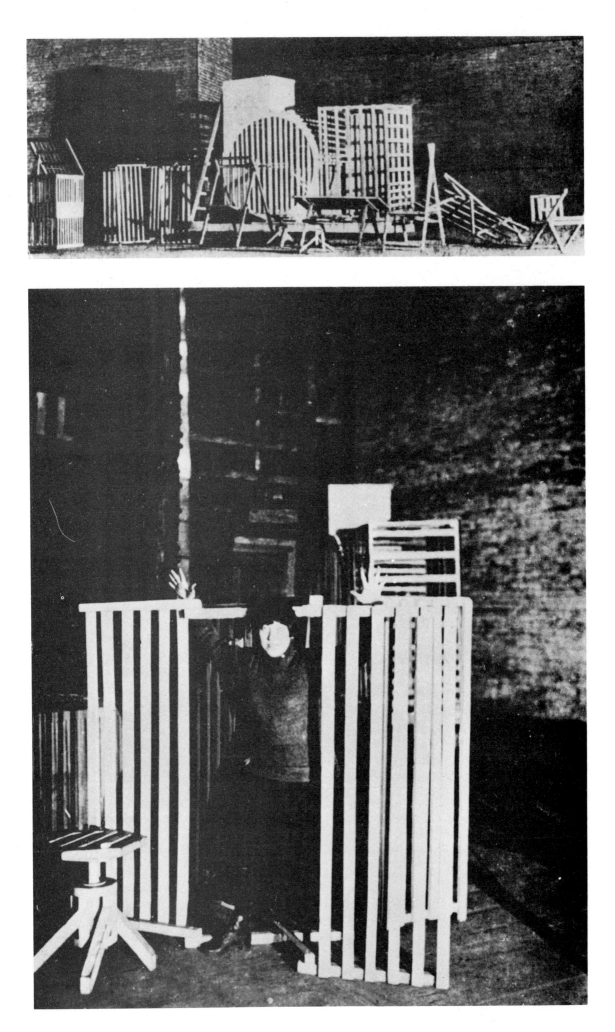

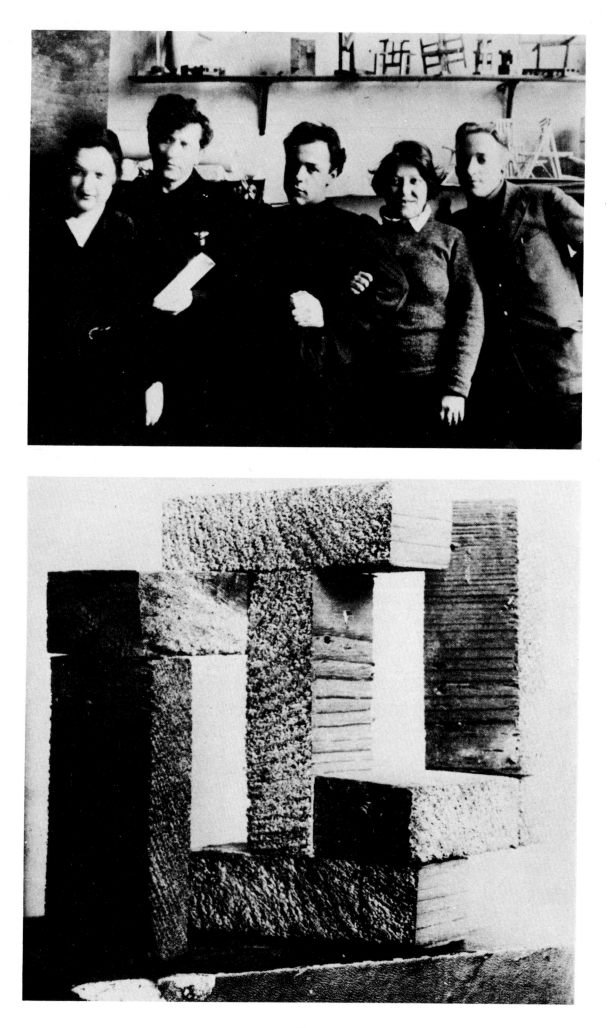

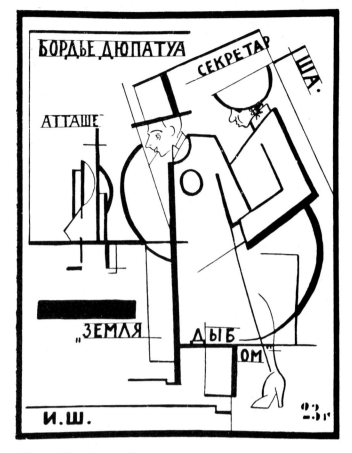

(Plate 88). Whilst Shukhov's tower stood as a practical technical achievement of the new age, Tatlin's *Tower* was an image of a social driving force. Shukhov's tower has little cultural application, Tatlin's has its cultural context built in from the beginning. The function answered by Shukhov was that of sending and receiving radio signals, that answered by Tatlin was to condense a social energy into a potent public image, to crystallize a new collective identity. The diagonal thrust of the Tatlin *Tower* was its most innovatory and readily assimilable quality. There are drawings and sculptures by Rodchenko, the Stenbergs and Lissitzky which share it.

Whilst the early 1920s were impossible years for the practice of architecture, the very unlikelihood of actual construction tended to encourage rhetorical expression, an architectural equivalent of the *Rosta* posters. Following the precedent of Tatlin's *Tower*, a number of Constructivists, for example the theorist Alexei Gan and the designer Lavinsky, designed street kiosks for the dissemination of news and propaganda. The agitational kiosk became a new *métier* of construction. It was cheap, compared with architecture, declamatory and brand-new, an example of the new construction as well as a disseminator of its ideas. Tatlin provided another lead; his *Tower* united sculpture and architecture, just as his counter-reliefs had straddled the demarcation between sculpture and paintings. The agit-kiosks of Rodchenko and Klutsis follow in this lead; they were not sculpture or architecture, but constructions.

build the new world' on its erected screen. For many of the Constructivists, certainly for Popova, Stepanova and Rodchenko, this 'building' process found its wider expression in the enormous task of constructing a new way of life, of devising a new culture; its narrower expression lay in the construction of objects devised for the new society. Constructions built by Constructivists were images of the larger process. To construct, be it to construct a monument or a chair, was to mould the world of material into the outward form of the new society.

Vladimir Tatlin again provides an important source in his *Tower*, which, although scarcely realizable in terms of engineering and financially impossible, was nevertheless brilliant as rhetoric. It fascinated people by its optimism and its effectiveness as an image of society as a growing and ascending organism. The telescoping effect of the spirals, and the feeling that this structure is uncoiling, springlike and moves not heavenwards but forwards and upwards implied a dynamic growth and progress. This image of emergence was so vital and convincing that it was much emulated. It is informative as confirmation of its rhetorical, rather than practical, rôle to compare it with the Moscow radio tower put up later by the engineer Shukhov (Plate 87), which shares certain characteristics with Tatlin's *Tower*, in particular its scale, which is still smaller than Tatlin's intention, and its openwork spiral mesh. The Shukhov tower was used as an image on a cover by the Constructivist Alexander Rodchenko for Mayakovsky's book *The Flying Proletariat* in 1925

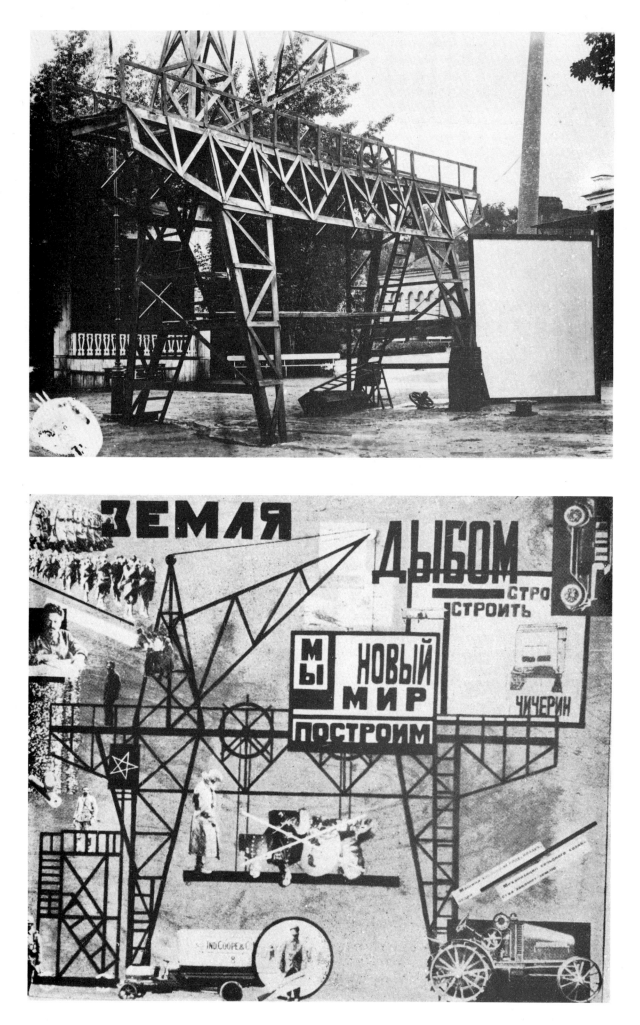

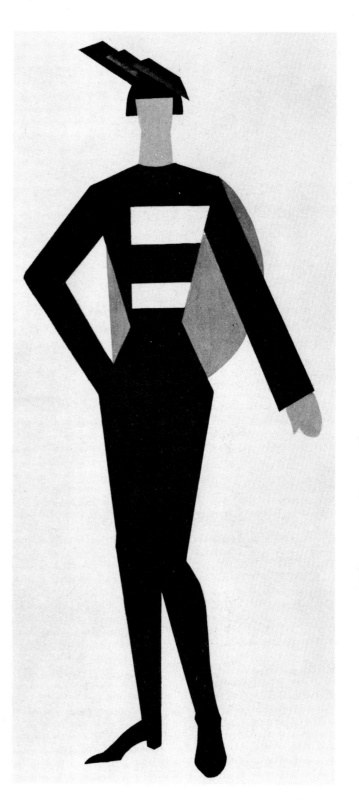

Klutsis designed a whole series of agit-kiosks (Plate 89) in 1922 in connection with a plan to broadcast Lenin's speeches. They incorporated screens and speakers and were based upon complex symmetries reminiscent of Rodchenko's models. Some of his drawings depict impossible structures. The principles of construction remain clear, however, and the impossibilities embodied in the drawings arise from a wilful denial of the laws of perspective like that enjoyed by Lissitzky (Plate 90). Klutsis's constructions have a collapsible look and clearly some pieces were intended to fold and unfold with screens emerging and sliding back flexibly (Plate 91). These strutting and gesturing objects have freshness and vitality. Their true function must be seen more in terms of their effectiveness as convincing eye-catchers and images of the means with which construction is involved, than as a straightforward attempt to make objects stand up as efficiently as possible. They have themselves the forceful and temporary look of posters and have to be seen in that light (Plate 92).

Perhaps the largest executed work of this whole *métier* was the one built by Alexandra Exter at the Agricultural Exhibition held near Moscow in 1923. Her tower, which used Suprematist forms as well as girders, glass and moving parts, was functional only in this rhetorical sense. It was a small exhibition pavilion dedicated to the journals *Izvestiya VTsIK* (*All Russian Central Executive Committee News*) and *Krasnaya Niva* (*Red Harvest*) so that it approached architectural scale (Plate 93). It remained, like Tatlin's *Tower*, common ground to architecture and sculpture.

The structure of Exter's exhibition tower was less lucid than Tatlin's, it could not be reconstructed logically, yet its thrusting arcs and scaffolding were declamatory and poster-like. Tatlin's diagonal structure, although absent from Exter's tower, was reflected in other projects. While Malevich used the diagonal constantly in his Suprematist canvases, it was never anchored in this way (Plate 94). Indeed, when Malevich turned to three-dimensional work in an architectural vein he kept conspicuously to right-angled forms and meticulously avoided the diagonal. His one time follower, Lissitzky, was much closer to Constructivism in this respect, as the *Lenin Podium* project from *Unovis*, the school run by Malevich and Lissitzky at Vitebsk, reveals. The *Lenin Podium* was, again, a declamatory work for a declamatory purpose.

It is possible to see in these monumental, ephemeral and often unexecuted works signs of a growing

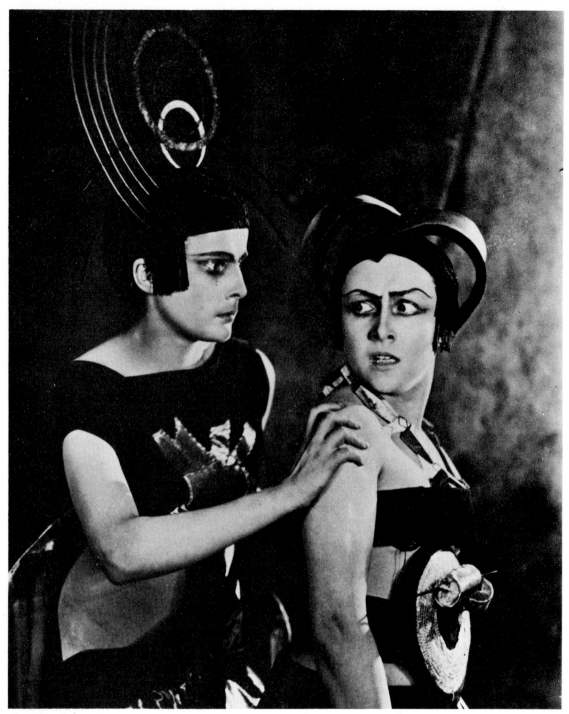

83 Alexandra EXTER
Still from the Film 'Aelita': Costumes and Sets
1924.

Theatrical designs can only provide suggestions of the impact made by completed costumes and
sets when employed on stage in actual performances. Apart from a few photographs and reports,
nothing remains of the performances themselves. The film *Aelita* overcomes this barrier and shows
Exter's designs in use, revealing directly all of their vitality and imagination.

(*opposite*)
VII Natan ALTMAN
Composition
LONDON, Annely Juda Fine Art. c. 1920. Painted wood 68·7 × 26 cm.

Natan Altman's paintings of the early post-Revolutionary period combined a handling of
geometrical forms with a vigorous grasp of material qualities. In this painting, *faktura,* the
manipulation of the painter's material, is a major consideration. The board, which supports the
painted forms, is left unobscured and its physical purpose is made evident. Upon it, basically
Suprematist forms are locked into a configuration suggestive of banners in movement, comparable
to his decorations for the Petrograd celebrations of 1918 (Plate 22). In contrast to this suggestive
element in the painting, the handling of paint as a material independent of representation, with a
variety of densities and textures, served to emphasize that the painting was a constructed object.

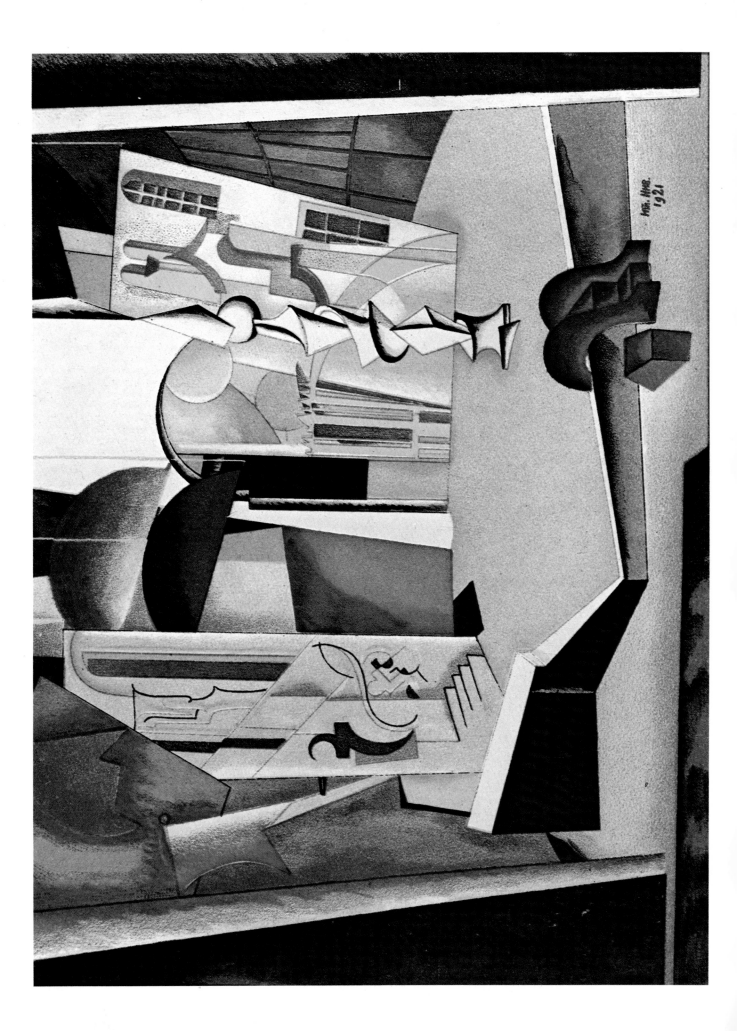

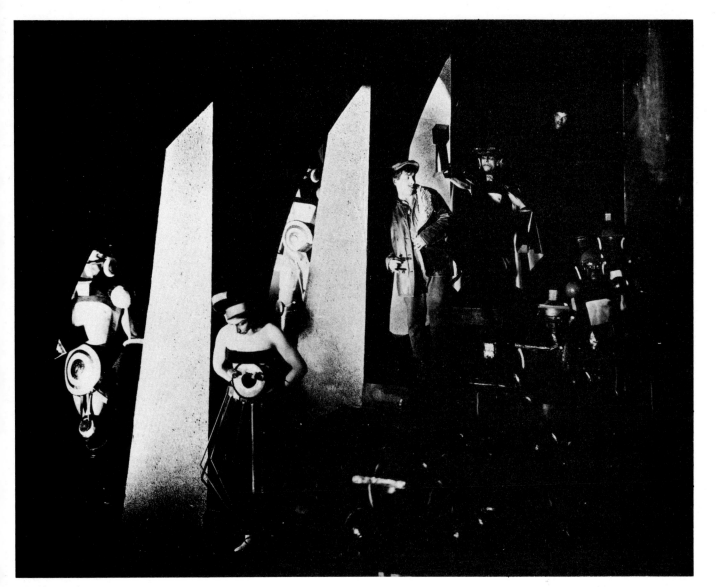

84 Alexandra EXTER
Still from the Film 'Aelita': Sets and Costumes
1924.

Soviet Earthmen are arrested at the Martian court and led to the chamber of the Martian queen.

(opposite)
VIII Ignats NIVINSKY
Set for Gozzi's 'Princess Tourandot'
NORTHUMBERLAND, collection of Kyrill Sokolov. 1921. 16 × 20 cm. Signed and dated lower right.

This lithograph by Nivinsky of his set for the 1921 production of *Princess Tourandot* at the
Vakhtangov Theatre in Moscow illustrates the adaptation of Constructivist devices to stylistic ends
which in themselves were incompatible with Constructivist ideals. Nevertheless, the sheer enjoy-
ment and vitality of Nivinsky's set is clearly evident and appropriate to the mood of exotic oriental
fantasy that pervades the play. The constructed column remained in evidence throughout the
performance whilst spectacularly coloured curtains and hangings transformed the set from interior
to exterior scenes at the Chinese Imperial Palace. Gozzi's play provided a perfect excuse for the
Russian love of fairy-tale and lavishly coloured costume. Nivinsky is in his own terms here as lavish
as the painters and designers of *Mir Iskusstva*.

architectural awareness amongst the followers of
Constructivism and Suprematism. This development
was also reflected in the teaching institutions set up in
Moscow, Petrograd and elsewhere, in the architectural
projects which have survived (Plate 95) and in the
enormous number of architectural groups and societies,
often with their own journals, that sprang into being
during the 1920s. Many schisms and factions developed

amongst their members. *Asnova* (the Association of New
Architects), of which Lissitzky was a member, evolved
an architectural style which theoretically remained at
odds with the Constructivists on many points. Lis-
sitzky's own designs for skyscrapers, however, reveal, as
well as his usual forcefulness, a typically Russian
blending of sculptural and architectural feeling. Ma-
levich's 'arkhitektoniki' remain one step closer to

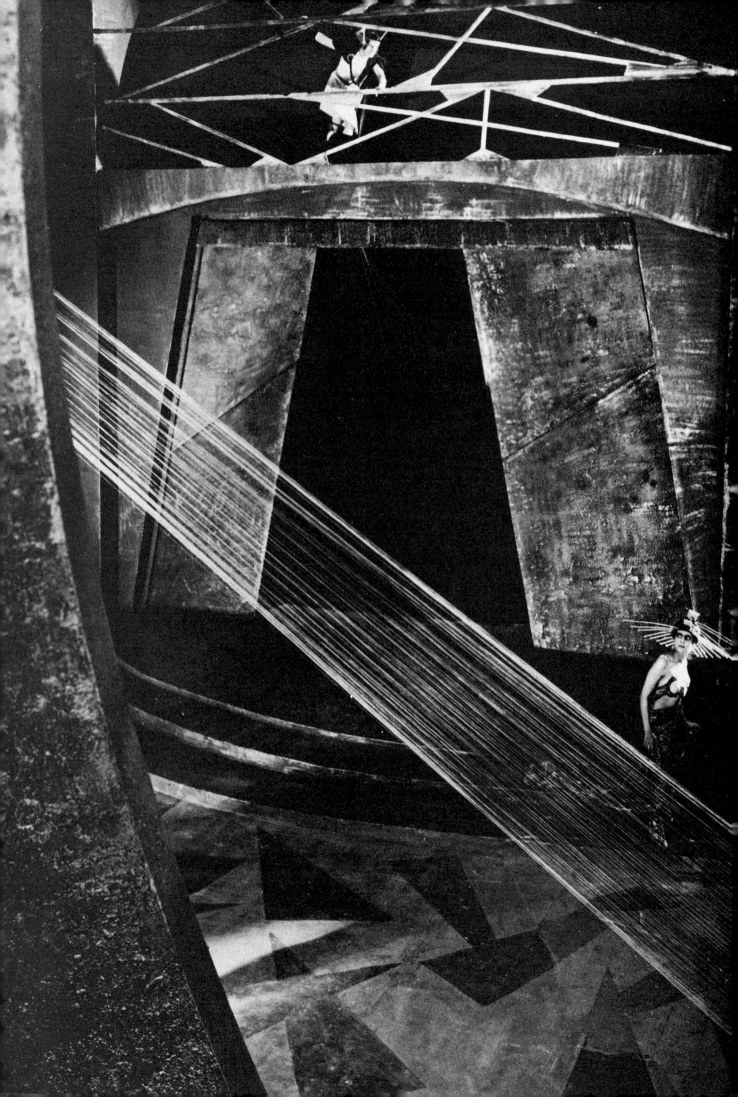

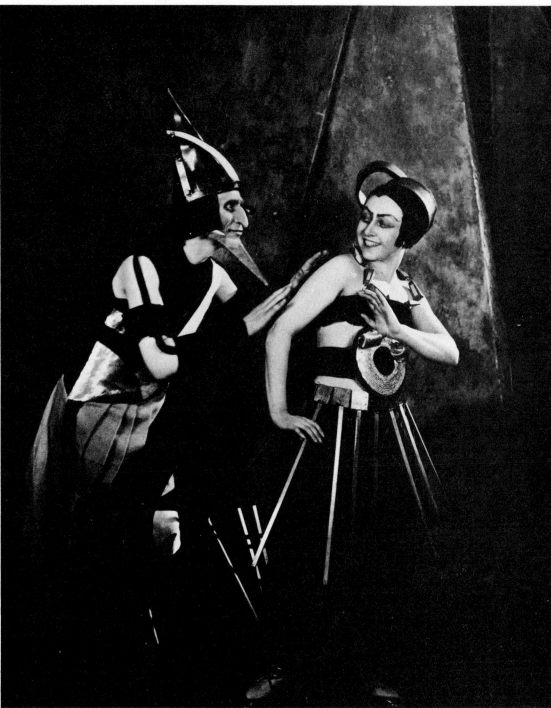

86 Alexandra EXTER
Still from the Film 'Aelita'
1924.

The film, directed by Protazanov and released in 1924, described the coming of revolution to the planet Mars. The costumes and sets for the Martian court were designed by Exter. In this still, Aelita's servant is approached by an ageing courtier. Her pantaloons are made from rigid wooden units which are attached by hinges to the waist and ankles, with a further hinge at knee height. The actress becomes a startling mechanistic creature full of rhythm, for the pantaloons flex as she walks.

(*opposite*)
85 Alexandra EXTER
Still from the Film 'Aelita': Part of the Martian Palace
1924.

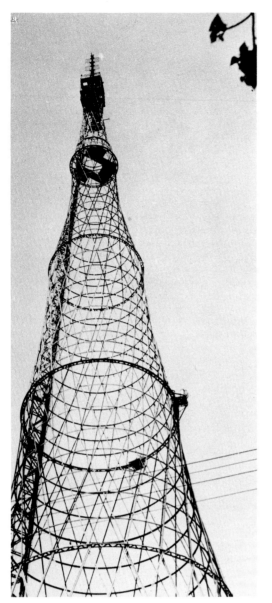

(*above left*)
87 A. V. SHUKHOV
Radio Mast, Moscow
1926. Documentary photograph.

In its spiral construction, diagonal support running the whole length of the tower on the left and horizontal strengthening rings, this engineering structure possesses many of the features foreshadowed in Tatlin's *Tower* of 1919–20.

(*above right*)
88 Alexander RODCHENKO
Book Cover for 'The Flying Proletariat'
1925.

Vladimir Mayakovsky's work was published by *Aviokhim* in Moscow in 1925. The central tower is that by the engineer, Shukhov (Plate 87).

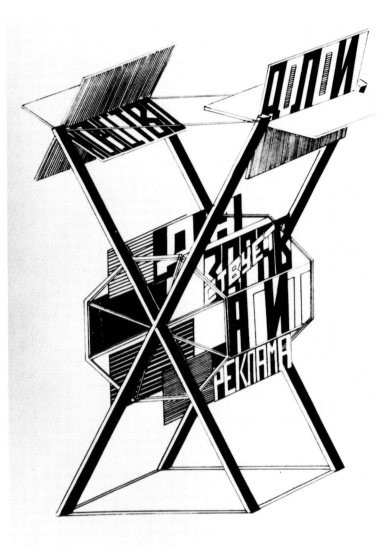

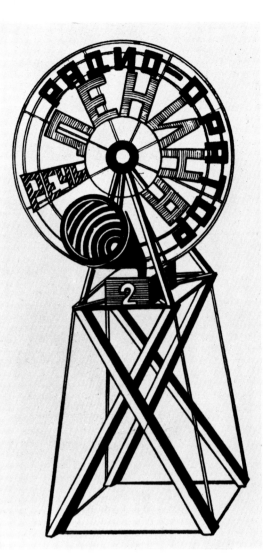

(above left)
89 Gustav KLUTSIS
Project for an Anti-art Propaganda Kiosk
c. 1922.

The three revolving sections bear the slogan 'Down with Art! Long live the Agit-poster.'

(above right)
90 Gustav KLUTSIS
Design for a Propaganda Speaker
1922.

The second of a series, inscribed 'Radio-orator. Lenin's speech', this design is deceptive in its apparent simplicity and, as a structure, is not in fact rigid. Klutsis had been a follower of Malevich and Lissitzky. Here he appears much closer to the Constructivists who exhibited at *Obmokhu* during the previous year. More up-to-date and still Constructivist is the commitment of principles of construction to an agitational purpose.

sculpture than Lissitzky's, yet their architectural feeling is obvious, particularly if his models are compared with those of Van Doesburg or Rietveld in Holland (Plates 96 and 97). The designs of the architect Ladovsky are also modelled with a strong sculptural emphasis as is the Dobuzhinsky Square project devised by the architect Krinsky with its curious packaged appearance which results from lavishly mixing scale and different types of fenestration on his building (Plates 98 and 99).

Within the circle of strict Constructivists, Alexander Vesnin provided a vital link with those who had worked on the small scale and on theatrical sets and mechanisms. His two brothers, Leonid and Viktor, were both active as architects. Alexander Vesnin worked with them on a number of projects in the early 1920s which have come to represent the first full expression of Constructivist thought applied to specific building projects of a practical nature.

In 1923 the government announced an architectural competition which in effect marked the beginning of the Soviet era of Russian architecture. The competition was for a new kind of public building, the Palace of Labour, which was to contain a radio station as well as

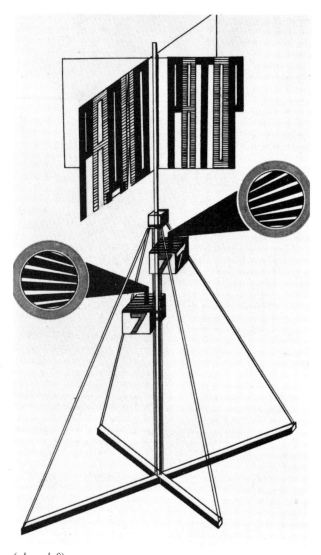

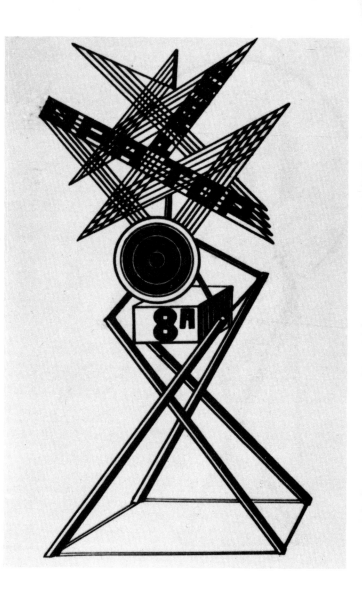

(*above left*)
91 Gustav KLUTSIS
Design for a Propaganda Loudspeaker Kiosk
1922.

The seventh of the propaganda series was inscribed on the rotating sails with the word 'Radiorator' ('radio orator', the words sharing the cental 'o').

(*above right*)
92 Gustav KLUTSIS
Design for a Propaganda Loudspeaker
1922.

Numbered '8a' in the series, this loudspeaker was inscribed on the upper part 'Radio Orator.' Klutsis, in designing a structure, retained a very keen eye for the placement of the forms as much across the page as in three-dimensional space, for example in his reduction of the loudspeaker to a series of concentric circles.

lecture halls and offices. The Vesnins' entry was a design for a massive building bristling with antennae, displaying a digital clock and incorporating a high elevated bridge. It was palatial and had the weight and imposing strength of the palace that its title suggests. The only Constructivist features were its clear, unadorned exterior, its dramatic bridge and the romantic paraphernalia of modernity in its clock and antennae. Its weight and sheer bulk were the antithesis of the vitality of smaller works and projects by Constructivists.

It can have been no easy matter to translate the rhetorical language of Constructivism into a practical language. More traditional functions had to be satisfied if Constructivism was to form an architectural expression. Furthermore, it was to be expected that new types of building would emerge, as did the workers' club for which no architectural precedent was available.

The Palace of Labour project was not realized and neither was the Vesnin brothers' next architectural competition project. This competition was for the Moscow offices of the newspaper *Leningrad Pravda*. In these designs the Vesnins came their closest to a feasible architectural expression of Constructivism. It was a

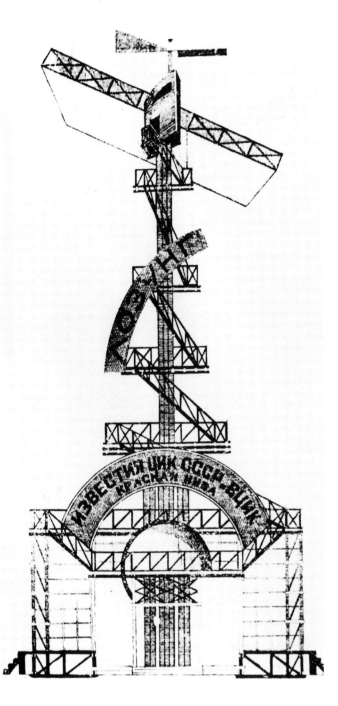

93 Alexandra EXTER with the architects MUKHINA and GLADKHOV
Design for an Exhibition Pavilion
1923.

The pavilion was designed for and erected at the All-Russian Architectural Exhibition in Moscow in 1923 for the periodicals, *Izvestiya VTsIK (All-Russian Central Executive Committee News)* and *Krasnaya Niva (Red Harvest)*. The exhibition was one of the first opportunities for Soviet architects and Constructivists to put their recent discoveries into practice in public buildings, however impermanent. The arc, halfway up the mast of the pavilion, simply reads 'slogan'.

94 Kazimir MALEVICH
A Page from 'Suprematism: 34 Drawings'

The work was published in Vitebsk in 1920 and was a survey of the chief innovations of Malevich's Suprematism from the *Black Square* onwards.

synthesis of themes from smaller constructions and recalls in particular Alexander Vesnin's flexible set for *The Man Who Was Thursday* with its openwork lift and its screen. On the *Leningrad Pravda* design the lifts are visible climbing through the steel and glass structural framework of the building. The digital clock appears more at home here than on the Palace of Labour and the news-screen is feasible. The emphasis upon construction is clear to see. The project is startling in the abruptness of its contrast with the massive box-like Palace of Labour.

The only Soviet building to reflect Constructivist thinking to be built outside the Soviet Union was an exhibition building and, therefore, ephemeral. This was the Soviet Pavilion designed by the architect Konstantin Melnikov for the Paris Exhibition of Decorative Arts of 1925 (Plate 100).

Rodchenko travelled with Melnikov to Paris and was responsible for the design of a reading room for a workers' club (Plates 101 and 102) set out in the pavilion to contrast with the lavish displays of Art Déco exhibited by many of the other pavilions and for which the Paris Exhibition of 1925 is still remembered. The pavilion contained works by many of the Constructivists, but was strongly devoted to Constructivism applied to the theatre, architecture, textile design, graphic work and posters. In other words it represented Productivist output, rather than Constructivist investigation. The main theoretical writers of the movement had elucidated this standpoint and a number of historically important texts had emerged, amongst them *Constructivism* by Alexei Gan (1922) and *From the Easel to the Machine* by Nikolai Tarabukin (1923). Rodchenko wrote:

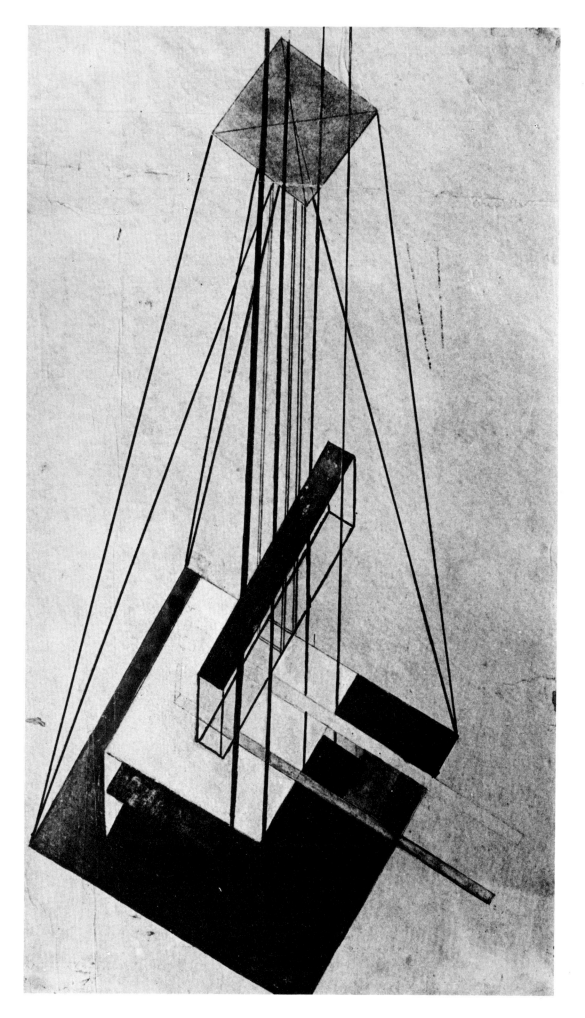

(*opposite*)
95 Gustav KLUTSIS
Architectural Study
LONDON, Annely Juda Fine Art. 1920. Gouache, indian
ink and pencil on paper 39·5 × 24·8 cm.

Axionometric projection is used consistently to permit
Klutsis to work ambiguously between pictorial construc-
tion on the one hand and architectural construction on
the other.

(*above*)
96 Kazimir MALEVICH
Architectonic
Whereabouts unknown. c. 1929. Documentary photo-
graph.

During the 1920s Malevich worked on a number of
models with a strong architectural theme. They remained
formal studies with no specific project in view, but they
defined a range of relationships of forms which echo those
of recent Western European architectural developments
in Holland, France and Germany.

(*right*)
97 Kazimir MALEVICH
Homes for Earthdwellers
AMSTERDAM, Stedelijk Museum. c. 1924. Pencil on paper
29·8 × 45 cm.

During the 1920s Malevich evolved three-dimensional
studies that approximated to architectural designs based
upon rectangular forms that first emerged in his Supre-
matist paintings. In drawings associated with these three-
dimensional works, Malevich is still able to deny the
problems of gravity and to depict his *Homes for Earth-
dwellers* suspended in space.

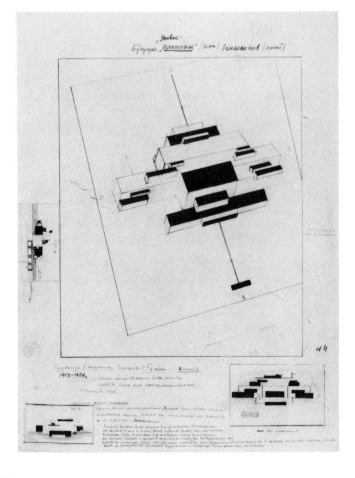

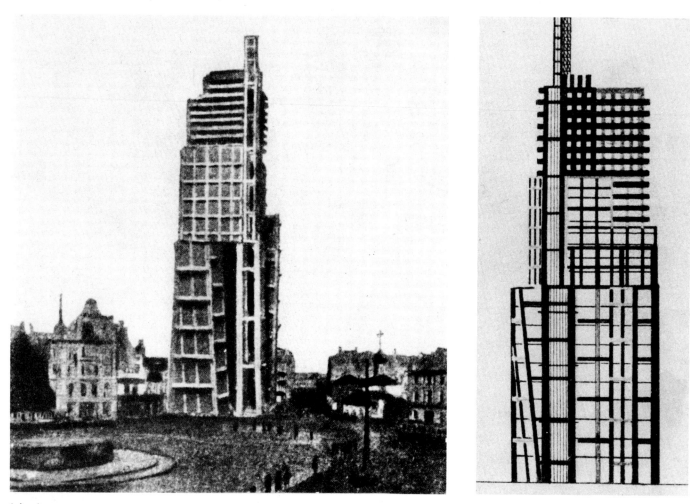

(above)
98 and 99 Viktor KRINSKY
Skyscraper Project for Dobuzhinsky Square, Moscow
1923.

The Plates show the photomontage view (Plate 98) and elevation of the façade (Plate 99).
Sculptural complexity of form and surface on an architectural scale were characteristics of much of
the architecture which arose from Constructivist and Suprematist roots in the 1920s. Krinsky's
Project is monumental, complex and densely packed together.

(opposite)
100 Konstantin MELNIKOV
Soviet Pavilion
1925. Documentary photograph.

The pavilion was designed and built for the Paris Exhibition of Decorative Arts in 1925. The stairs
progressed at an acute angle up to doors on the first floor. A similar approach was possible from
the other side of the pavilion. At ground floor level the two halves of the building flowed together
under the stairs.

In 1921 I stopped painting completely, I devised the slogan 'representation is finished, the time has come for construction' and I went into production. I was head of the metal workshop at *Vkhutemas* and in charge of projects. Out of the very same department which had once made mounts for icons, lamps and other church plate, there began to emerge constructors producing electrical devices, metal objects of daily use, and metal furniture' [Plate 105].

If Melnikov's pavilion, with its interslotting roofs and rhomboid plan with steps from corner to corner, recalled the strange symmetries of agit-kiosks (Plates 106 and 107), it was to be expected in the context of an international exhibition in which the architect was obliged to present an image of simultaneous energetic inventiveness and simplicity of means. Rodchenko's club room was anything but modish or smart, a severe interior housing furniture made from undecorated wood simply and directly used. It must have provided an uncomfortable contrast with the lavish décor of most of the pavilions, and even with the space-age modernity of Le Corbusier's Pavilion de L'Esprit Nouveau with its tubular furniture, its Léger paintings and its tree growing through the roof. The contrast implied, between Constructivist design and contemporary Western design, was heightened by the fact that Rodchenko and Tatlin designed utilitarian clothes. Style was not the order of the day and in this the Russians were distinct from many contemporaries at

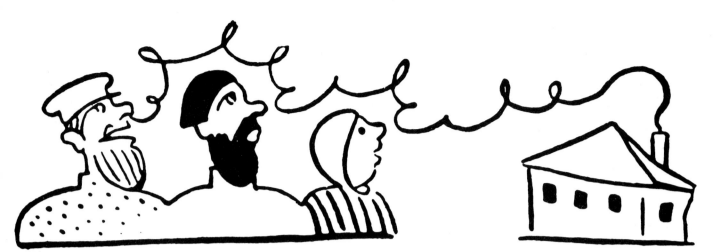

103 Vladimir MAYAKOVSKY
Illustration to his Agitpoem 'Down with Home-brewed Drink!'
1923. Indian ink.

Peasants inhabit many of Mayakovsky's drawings. An awareness of the peasant population and of the worker remained as important an element in Constructivism as did the forms and materials of the technological West. Rodchenko's Workers' Club at the 1925 Paris Exhibition clearly illustrated this amongst the elegance and tastefulness of many of the other pavilions.

(opposite top)
101 Alexander RODCHENKO
Workers' Club Reading Room
1925. Documentary photograph.

In this interior view of the Soviet Pavilion at the Paris Exhibition of Decorative Arts in 1925, the bookshelves, table and chairs were all designed by Rodchenko, as was the chess table with chairs attached which is visible at the far end of the room.

(opposite bottom)
102 Alexander RODCHENKO
Workers' Club Reading Room
1925. Documentary photograph.

The lamp for the Reading Room was also designed by Rodchenko (Plate 105), as was the poster for Dziga Vertov's *Kino-Eye* films, visible on the far wall.

this Exhibition. Yet by 1925 the 'International Style' of architecture had arisen which cultivated unadorned walls and exposed the construction and materials which made up a functional object. Soviet bentwood and metal chairs are directly comparable with chairs by Le Corbusier, Marcel Breuer and others. As the 1920s progressed, architects in the Soviet Union were increasingly drawn into the broader developments of the international modern movement. Western architects visited Moscow and when they entered the 'Palace of the Soviets' architectural competition, they responded to Russian architectural themes. Le Corbusier's design for this competition illustrates this well with its suspended volumes, revealed supports and parabolic arch.

Le Corbusier visited Moscow in connection with the large Tsentrosoyuz store which he built there in collaboration with Soviet architects. His influence in the Soviet Union was considerable; he was especially admired in Constructivist circles by the Vesnin brothers and the younger Constructivist architect Moisei Ginzburg.

Although both Melnikov and the Vesnins devised solutions to the new building-type, the workers' club, which were strong and flexible, that other new type of building, the communal house, was closer to Le Corbusier's own interests. Both Le Corbusier and Walter Gropius devised complex buildings in which student accommodation was combined with other functions.

By the later 1920s only one architect had emerged to carry specifically Constructivist ends further. This was Ivan Leonidov whose spacious and frail structures bring an acute sense of interval and poise to designs thoroughly Constructivist in their skeletal glass and steel units and their sculptural complexity (Plates 109 and 110).

One of the most singular qualities of Constructivism was that it not only spread its influence into many and diverse fields, embracing every opportunity for more public expression, but, in reaching fruition, by turning to practical design work in the theatre, in architecture and in the making of useful objects ranging from folding chairs to stoves, it simultaneously began to disperse itself and even to disappear.

In Russia very many creative people, including writers and architects, were affected by its passage. They had devised an image of the 'City of the Future',

104 Alexander RODCHENKO
Design for the Entrance to the Workers' Club
1925. Red and black ink.

This structure appears at the back of the Reading Room
(Plate 102). It is inscribed on the left 'Workers' Club'.

105 Alexander RODCHENKO
Design for a Lamp to Illuminate a Room and Table
1924–25. Ink and gouache.

This lamp was used at the 1925 Paris Exhibition (Plate
102), and its plan, elevation and diagram show how the
bulb may be moved within the lamp to project light
upwards or downwards.

(*above left*)
106 Gustav KLUTSIS
Small Rostrum on a Triangular Base
c. 1922. Ink.

This 'agit-kiosk' is a complex structure in which the triangle forming the base of the top of the rostrum is a reversal of that triangle on which the whole structure stands. Klutsis's drawing is full of the contradictions which he loved to include surreptitiously in his drawings of constructions.

(*above right*)
107 Gustav KLUTSIS
Structural Study for a Rostrum
c. 1922. Ink.

The structure appears simpler than it is. The legs comprise four cross-shaped units which together house steps.

(*right*)
108 Fernand LÉGER
Charlie Chaplin

This image was published in Ilya Ehrenburg's book *And Still It Turns* in Berlin in 1922. Both Chaplin and Léger were admired amongst Constructivists in Russia and Ehrenburg shared their enthusiasm.

had described in it the 'New Man' and had provided some of the means for his emergence. The future was by no means for the superhuman, nor was it exclusively mechanistic. If Constructivism contained Utopian dreams, it was, nevertheless, based in physical experience and its possibilities within post-Revolutionary society. The image of flight recurs in Constructivist works as an expression of freedom of movement. Mayakovsky wrote *The Flying Proletariat* in 1925, Tatlin, completely turning his back on metallic technology, produced a glider, Malevich had dreamt of flying cities and Lavinsky began to design a Utopian city on springs. Lissitzky's photomontage and Rodchenko's photograph of the diver show the 'New Man' in that flight (Plates 111 and 112). Yet Rodchenko's man is a

physical being and his performance can be learned. He is a real creature of flesh and blood and does not occupy some remote and idealized world of art. His perfection can be grasped (Plate 113).

This aspect of Constructivism was its most realistic aspect. Constructivism could comment and work directly with the material of daily life and nowhere was it able to do this more immediately, intelligibly and universally than in film. With the alliance between Mayakovsky, Rodchenko and other Constructivists and the film directors Sergei Eisenstein and Dziga Vertov around the periodical *Lef* (*The Left Front of the Arts*) (Plate 114), which was first published in 1923, Constructivism found a new and vital expression. In film, Constructivism finally became universally

ca 5 1930

современная архитектура

к дискуссии о дворцах культуры

дворец культуры

и. леонидов

общий фасад

109 Ivan LEONIDOV
Project: *Palace of Culture Competition*

This general elevation was published in *Sovremennaya Arkhitektura* (*Contemporary Architecture*) 1930, No. 5. The design is sparse, poised and rhythmically proportioned.

110 Ivan LEONIDOV
Lenin Institute
1927.

The spherical form to the right in this elevation was intended to provide an enormous assembly hall.

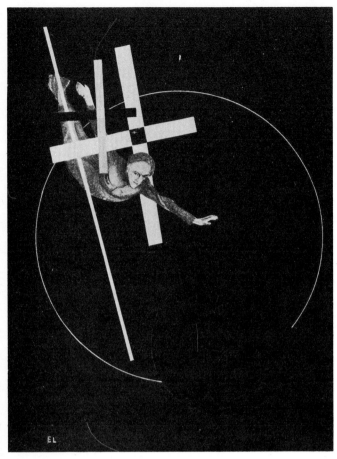

(*above left*)
111 El LISSITZKY
The Black Sphere
1922. Collage.

The Black Sphere was an illustration for *Six Tales with Easy Endings* by Ilya Ehrenburg, which was published in Moscow and Berlin in 1922.

(*above right*)
112 Alexander RODCHENKO
The Dive
1936. Photograph.

This image, as late as 1936, reveals Rodchenko attracted, in a thoroughly Constructivist way, to that seemingly effortless control of material existence of which the acrobatic dive appears to be so perfect an example.

accessible and universally intelligible.

It is in film that Constructivist technique finds its final expression (Plate 115). Both Eisenstein and Vertov pay full heed to the material at their disposal and its rôle in the construction of the whole. Both, for example, use cutting as a rhythmic device, that accompanies and underlines the action of the films. In the work of both, the viewer is aware of the cameraman's eye selecting and the director's eye editing. In Dziga Vertov's film *The Man with The Movie Camera* the Constructivist's preoccupation with the reality of daily life is at its height and the viewer is inevitably aware of the cameraman as he can see him or his colleague at work. His subject, far from being a tale of revolution on Mars, or an historical event recreated, was the city itself revealed as a waking, living and sleeping organism with no single story and a million small events (Plates 116–119). Vertov, like Maya-kovsky, revealed that the 'City of the Future' was only the potential form of the city of today and that it was in the making. In *The Man with The Movie Camera*, construction was made intelligible and evoked the social dimension, the rejection of illusionism and a convincing revelation of the social organism to itself.

114 Alexander RODCHENKO
Osip Brik
COLOGNE, Galerie Gmurzynska. c. 1923. Photograph.

Rodchenko pointed to Brik's central rôle in founding and editing the periodical *Lef* (*Left Front of the Arts*) with Vladimir Mayakovsky, by inserting the title of the periodical into his spectacle frame. Rodchenko worked as a designer for *Lef* from its beginning in 1923.

(*opposite*)
113 Alexander RODCHENKO
On the Parallel Bars
1938. Photograph.

Sport for the Constructivists comprised an example of art-into-life, for it emphasized the human frame as material substance. Its perfections lay beyond questions of taste and illusion associated with art and it was popularly enjoyed and respected.

115 Anton LAVINSKY
Poster for the Film 'Battleship Potemkin'
1926.

The poster is dynamic and forceful. The rigidly symmetrical image is built up by Constructivist means, for the lines suggesting rigging and wires have no specific representational rôle, but are crucial to the fierce energy of the poster's impact.

(opposite)
116 and 117 Dziga VERTOV
Stills from the Film 'The Man with the Movie Camera'
1929.

Vertov's *The Man with the Movie Camera* was so closely tied in with the Constructivists' aim of avoiding illusion and focusing creative work on life itself that this film of the city as a living entity becomes a brilliant revelation of the city to its own inhabitants and creators.

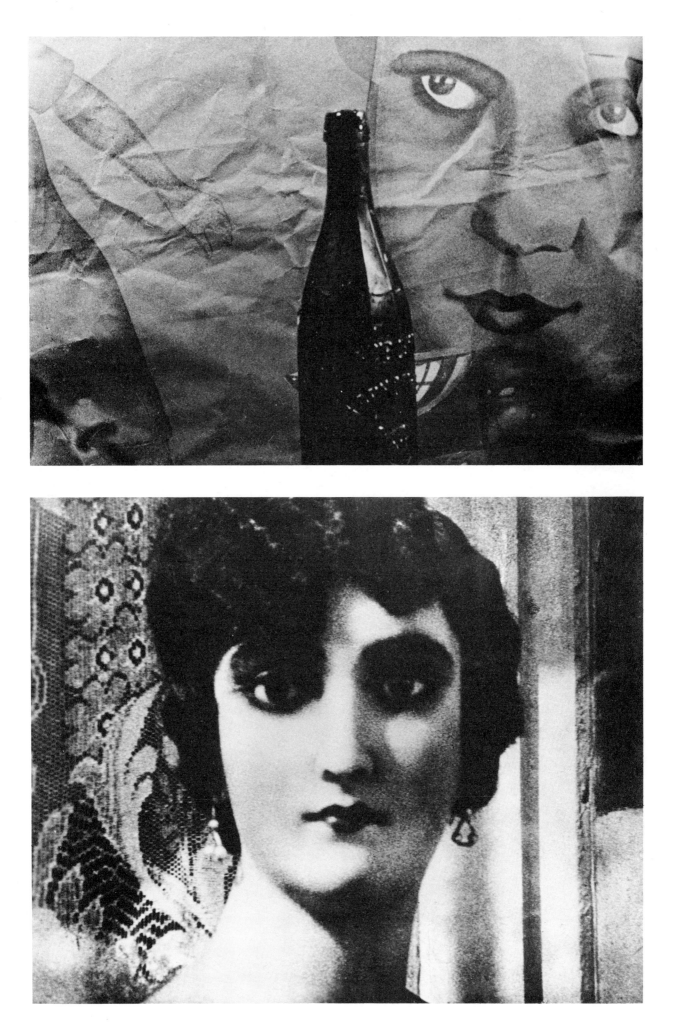

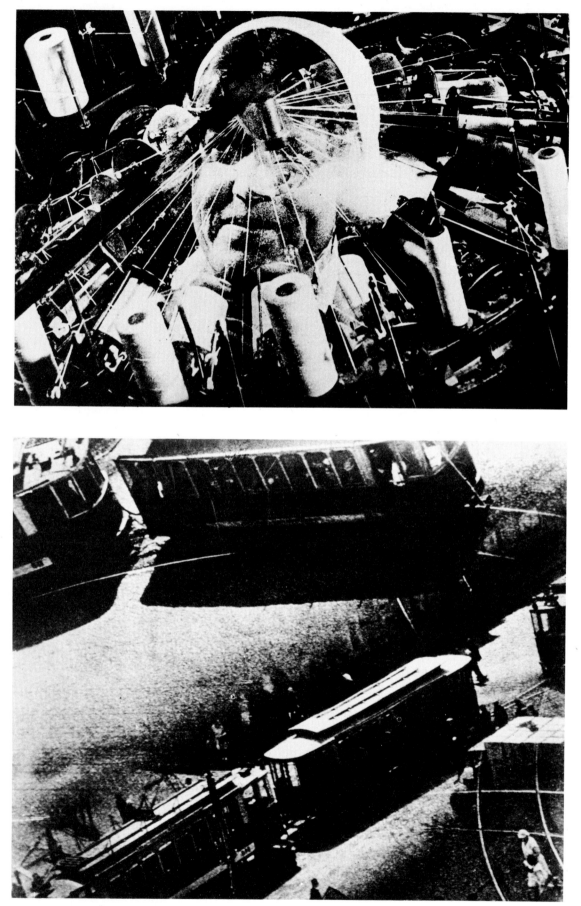

118 and 119 Dziga VERTOV
Stills from the Film 'The Man with the Movie Camera'
1929.

Selected Bibliography

Izobrazitel'noe Iskusstvo (*The Plastic Arts*), periodical, No. 1. Petrograd, 1919.

Arthur Ransome, *Six Weeks in Russia in 1919.* Glasgow, 1919.

Konstantin Umanskij, *Neue Kunst in Russland 1914–1919.* Potsdam and Munich, 1920.

Vladimir Mayakovsky, *Misteriya-Buff* (*Mystery Bouffe*). Moscow, 1921. The most recent English translation is Guy Daniels's *The Complete Plays of Mayakovsky*, New York, 1971.

Nikolai Punin, *Protiv Kubizma: Tatlin* (*Against Cubism: Tatlin*). Petrograd 1921.

Yakov Tugendhold, *Alexandra Exter.* Berlin, 1922.

Erste Deutsche Kunstaustellung, Van Diemen Gallery, Berlin, exhibition catalogue, 1922.

Veshch' – Objet – Gegenstand, periodical (eds. El Lissitzky & Ilya Ehrenburg). Berlin, 1922.

Alexei Gan, *Konstruktivizm* (*Constructivism*). Tver', 1922.

Ilya Ehrenburg, *A Vsyo-taki ona Vertitsya* (*And Still It Turns*). Moscow and Berlin, 1922.

Alexander Taïrov, *Zapiski Rezhissera* (*Notes of a Director*), Moscow, 1921; English translation by W. Kuhlke, Miami, 1969.

Vladimir Mayakovsky, *Pro Eto* (*About This*), with Rodchenko photomontages. Moscow and Petrograd, 1923.

Boris Arvatov, *Iskusstvo i Klassy* (*Art and Class*). Moscow and Petrograd, 1923.

Nikolai Tarabukin, *Ot Molberta K Mashine* (*From the Easel to the Machine*), Moscow, 1923; incorporated in French translation in *Nikolai Taraboukine Le Dernier Tableau* (ed. Andrei B. Nakov). Paris, 1972.

Lef (*Left Front of the Arts*), periodical (eds. Vladimir Mayakovsky and Osip Brik). Moscow, 1923–25.

Kazimir Malevich, *Die Gegendstandslose Welt* (*Non-objective World*). Munich, 1927.

Gabo, published by Lund Humphries. London, 1957.

Jay Leyda Kino, *A History of the Russian and Soviet Film.* London, 1960.

Camilla Gray, *The Great Experiment: Russian Art 1863–1922.* London, 1962.

Lubomir Linhart, *Alexandr Rodčenko.* Prague, 1964.

Troels Andersen, *Vladimir Tatlin,* Moderne Museet, Stockholm, exhibition catalogue, 1968.

Sophie Kueppers – Lissitzky, *El Lissitzky.* London, 1968.

Leonid Filippovich Volkov – Lannit, *Aleksandr Rodchenko, Risuet, Fotografiruet, Sporit* (*Alexander Rodchenko, Drawing, Photographing and Arguing*). Moscow, 1968.

Kazimir Malevich, *Essays on Art* (ed. Troels Andersen). Copenhagen, 1968.

Vladimir Markov, *Russian Futurism.* Los Angeles, 1968.

Meyerhold on Theatre (ed. Edward Braun). London, 1969.

Anatole Kopp, *Town and Revolution. Soviet Architecture and City Planning 1917–35.* New York, 1970.

Viktor Shklovsky, *Sentimental Journey. Memoirs, 1917–1922.* Ithaca, New York, 1970.

Constructivist Architecture in the USSR, special issue of *AD* periodical. London, 1970.

Troels Andersen, *Malevich,* Stedelijk Museum, Amsterdam, exhibition catalogue, 1970.

Benedikt Livchitz, *L'Archer à un Oeil et Demi*. Lausanne, 1971.

Art in Revolution, Hayward Gallery, London, exhibition catalogue, 1971.

Wyktor Woroszylski, *The Life of Mayakovsky*. London, 1972.

Viktor Shklovsky, *Mayakovsky and his Circle*. New York, 1972.

Russian Constructivism Revisited, University of Newcastle upon Tyne, exhibition catalogue, 1974.

The Tradition of Constructivism (ed. Stephen Bann). London, 1974.

German Karginov, *Rodcsenko*. Budapest, 1975.

Andrei B. Nakov, *2 Stenberg 2*, Annely Juda Fine Art, London, exhibition catalogue, 1975.

The 1920's in Eastern Europe, Galerie Gmurzynska, Cologne, exhibition catalogue, 1975.

Russian Pioneers: at the origins of non-objective art, Annely Juda Fine Art, London, exhibition catalogue, 1976.

Die Kunstismen in Russland 1907–1930, Galerie Gmurzynska, Cologne, exhibition catalogue, 1977.

Constructivism, Council of Europe, Berlin, exhibition catalogue, 1977.

V. E. Tatlin, Soviet Artist's Press, Moscow, exhibition catalogue, 1977.

Ex Libris 6: Constructivism and Futurism: Russian and Others T.J. Art Inc., New York, 1977.